IMAGES
of America

CLEVELAND'S
NATIONAL AIR RACES

D1600251

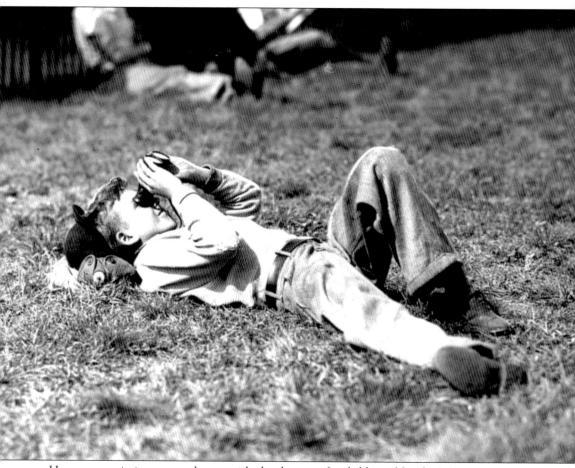

How many aviation careers began with the dreams of a child just like this? A young spectator enjoys the National Air Races during the 1930s. (*Cleveland Press* Collection, CSU.)

On the cover: Roscoe Turner poses with his Laird-Turner Racer on the last day of August 1939. He was about to fly this airplane into the history books as the only three-time winner of the Thompson Trophy. Last flown in 1940, Turner's racer survives today in the collection of the National Air and Space Museum. (*Cleveland Press* Collection, CSU.)

IMAGES
of America

CLEVELAND'S
NATIONAL AIR RACES

Thomas G. Matowitz Jr.

ARCADIA

Published by Arcadia Publishing
Charleston SC, Chicago IL, Portsmouth NH, San Francisco CA

Printed in the United States of America

Library of Congress Catalog Card Number:

For all general information contact Arcadia Publishing at: 2005933418
Telephone 843-853-2070
Fax 843-853-0044
E-mail sales@arcadiapublishing.com
For customer service and orders:
Toll-Free 1-888-313-2665

Visit us on the Internet at www.arcadiapublishing.com

In memory of
Bill Neff

CONTENTS

ACKNOWLEDGMENTS

It is a pleasure to thank the following people and organizations for their help with the preparation of this book.

At Cleveland's International Women's Air and Space Museum, Cris Takacs and Joan Hrubec were very generous with their time and the loan of invaluable research materials.

At Cleveland State University (CSU), Special Collections librarian William C. Barrow made more than 100 images from the *Cleveland Press* Collection available for my use. This is not the first time he has gone far out of his way to help me get a book into print, and I am very grateful.

Without the warm cooperation of Lynn Duchez Bycko from the Cleveland State University Library's Digital Production Unit, I am not sure the book would exist in its present form. Her constant help throughout this project is much appreciated.

My late friend, Jim Young, spent a lifetime collecting a wonderful assortment of aviation photographs. Several appear in this book with the kind permission of his family.

Karl Engelskirger taught me how to fly a tail dragger in the 1990s and has remained a close friend ever since. He provided critical leads to information and photographs that were extremely helpful.

Several outstanding photographs appear in these pages through the courtesy of Bernadine Crozier and Molly Tewksbury.

My friend and colleague Matt Grabski provided sound insights and good-natured encouragement as we researched two books concurrently. I hope his forthcoming Arcadia Publishing book about Cleveland's Flats reaches a wide audience.

In the course of a number of early morning conversations, my friend David C. Holcombe answered a wide range of air-racing questions with patience and accuracy.

Finally I thank Joe Binder, age 86, for his warmth, courtesy, and willingness to share both his personal photograph collection and his remarkable firsthand knowledge of golden age racing planes and the pilots who flew them.

Thomas G. Matowitz Jr.
Mentor, Ohio
September 15, 2005

FOREWORD

The majority of today's visitors to the Cleveland Hopkins International Airport notice nothing out of the ordinary. Only the most knowledgeable aviation enthusiasts among them realize that the skies overhead once reverberated with the roar of radial aircraft engines and the cheers of 100,000 spectators.

For 20 years, from 1929 to 1949, the world's attention focused on the National Air Races every Labor Day. With rare exceptions, the event was hosted by the Cleveland Municipal Airport.

Established in 1925, this facility for many years was the world's largest airport. Located on the city's far southwest side, the 1,000-acre grass field provided airmail facilities, a passenger terminal, and modern hangars, as well as bleachers, parking, and concession stands sufficient to accommodate tens of thousands of visitors.

The events were planned and promoted very effectively. Cliff Henderson began flying early enough to solo an OX-5-powered Curtiss Jenny shortly after the First World War ended. By the late 1920s, he was recognized as one of the aviation industry's most skillful promoters. During his years in Cleveland, he had the hearty cooperation of Charles S. Thompson and, after Thompson's death in 1933, Frederick C. Crawford, both of whom led the Thompson Products Company, a major corporate sponsor of the event. Equally supportive was Louis W. Greve, the head of the Cleveland Pneumatic Tool Company, a manufacturer of aircraft landing gear components. The businessmen and promoters had excellent material to work with, considering the airplanes and pilots who dominated the era.

James H. Doolittle, an ex-army officer who had already made a remarkable name for himself as an air-racing pilot in the 1920s, gave the National Air Races one of its defining moments with his spectacular victory in the 1932 Thompson Trophy Race. Seen by many as a pure daredevil, Doolittle was nothing of the kind and actually held one of the first doctorates in aeronautical engineering earned in the United States. Doolittle generally wore a white shirt and tie when he flew and kept a low profile on the ground.

This was not true of his friendly competitor, Roscoe Turner. Turner grew up in a poor family in Corinth, Mississippi. He learned to fly after serving as a balloon observer in World War I. He carefully cultivated an image like no one else. He wore an elaborate waxed mustache and a resplendent aviator's uniform of his own design. Not satisfied with a mere dog or cat, Turner's mascot was a lion cub he named Gilmore, after a corporate sponsor. An early expert at gaining corporate sponsorships, Roscoe Turner's credentials as an air-racing pilot were beyond dispute. He was the only pilot ever to win the Thompson Trophy three times. He narrowly missed winning the race on two other occasions. His personal finances were almost as perilous

as his pylon racing. More than once, his racer was hidden from process servers until a last minute victory restored his fortunes.

While the races put on a remarkable show for the public, they served a very valid practical purpose, introducing a wide range of technical innovations that proved to be of great value to commercial and military aviation.

Along with the triumphs, the National Air Races provided its share of tragedies. No one ever tried to pretend that air racing was not dangerous. Crashes were frequent and took the lives of many well-liked pilots. The last straw occurred on September 6, 1949. Bill Odom, a pilot known primarily for his long-distance flights in light planes, was entered in the Thompson Trophy Race. His aircraft was a radically modified P-51C. Painted a dark metallic green and wearing the number seven, it was named *Beguine*. Despite having no prior experience pylon racing in high-performance aircraft, Odom had managed to win the Sohio Race several days earlier.

On September 6, his luck ran out. Attempting to round the second pylon during the first lap of the Thompson Trophy Race, Odom misjudged a turn, entered an accelerated stall, and lost control of his aircraft. Traveling in excess of 300 miles per hour, the P-51 crashed into a newly occupied house on West Street in Berea, Ohio. Odom was incinerated, along with a young mother and her child.

The column of smoke rising from Odom's crash cast a pall over the National Air Races from which there could be no recovery and effectively ended the event forever.

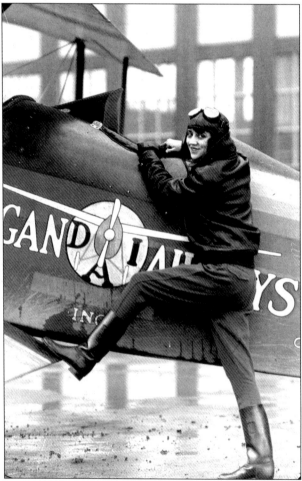

Blanche Noyes is seen here with the Waco 9 in which she learned to fly. The aircraft wears the logo of Dungan Airways, Inc., a fixed base operator located at the Cleveland Municipal Airport in the late 1920s. (*Cleveland Press* Collection, CSU.)

One

BEFORE THE RACES

Between 1903 and the first appearance of the National Air Races in Cleveland, aviation passed from infancy to late adolescence. Airplanes had become reliable but still had a long way to go to achieve widespread public acceptance. The following illustrations will show how aviation first reached Cleveland and give a sense of what airplanes were capable of at the dawn of the National Air Races.

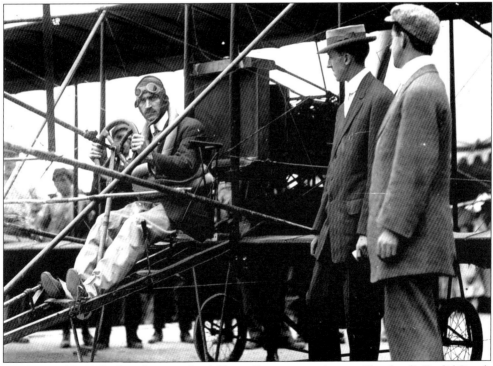

On August 28, 1910, this photograph of Glenn Curtiss was taken at Cleveland's Euclid Beach Park. It documents one of the earliest public demonstrations of an airplane in the area. (*Cleveland Press* Collection, CSU.)

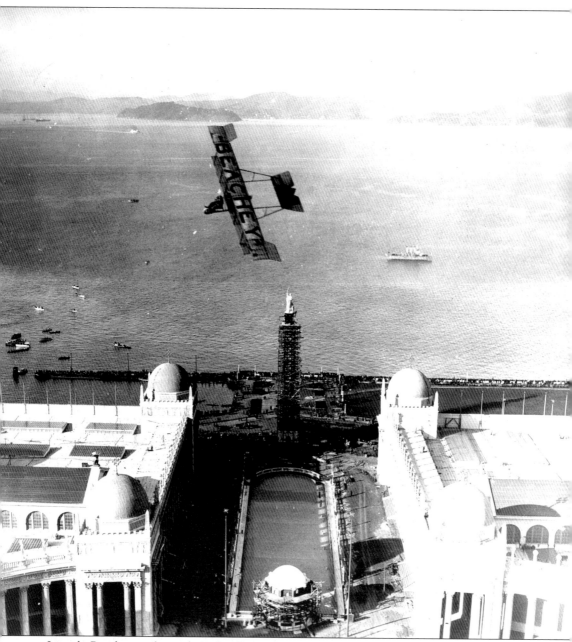

Lincoln Beachey performs above San Francisco's Panama-Pacific Exposition in 1915. It is unlikely that young men growing up in California at the time like Jimmy Doolittle, Cliff Henderson, and Al Menasco were unaware of his exploits. Shortly after this picture was taken, Beachey was killed when he over-stressed a new monoplane and crashed into San Francisco Bay. (*Cleveland Press* Collection, CSU.)

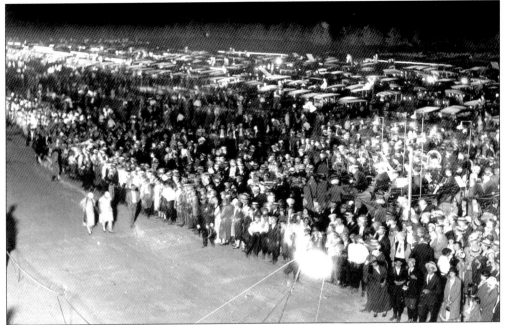

This is a portion of the crowd that gathered to witness the arrival of airmail flights on July 1, 1925, the Cleveland Municipal Airport's first day of operations. (*Cleveland Press* Collection, CSU.)

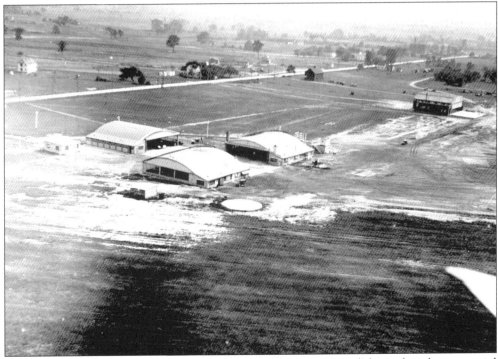

From the summer of 1926, this view, looking southeast, is one of the earliest known aerial photographs of the Cleveland Municipal Airport. Plainly visible in the center are the hangars built to service mail planes. (*Cleveland Press* Collection, CSU.)

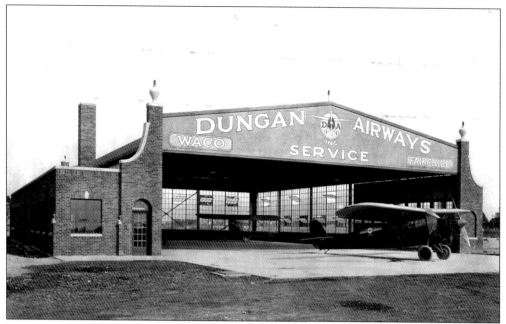

Located on the airport's east side, this hangar was the home of Dungan Airways, a short-lived fixed based operator that did business there in the late 1920s. Under new management, it served as the backdrop for many famous photographs in the 1930s. It was typical of the modern facilities that greeted visitors during the heyday of the National Air Races. (*Cleveland Press* Collection, CSU.)

Taken in June 1928, this view shows the new hangar built to house the Ohio National Guard observation squadron that was based at the Cleveland airport. Located on the south side of the field, this site vanished beneath the present-day International Exposition Center decades ago. (*Cleveland Press* Collection, CSU.)

Two

In 1929

When the air races came to Cleveland in 1929, aviation was barely 25 years old. Progress had been remarkable, and the use of airplanes was becoming less of a novelty. Visionaries could see great things in store and gathered in Cleveland to see their dreams realized. The city's airport had expanded rapidly to meet their needs, and Cleveland really did provide the best possible venue for the events about to unfold there.

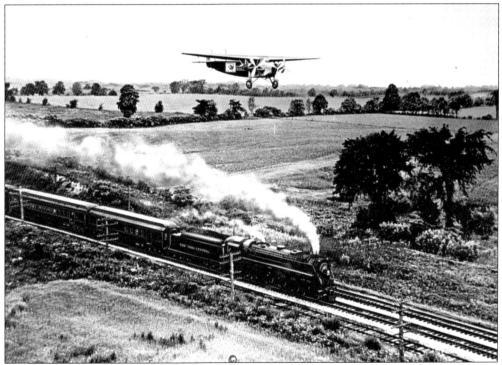

Probably the only time in aviation history when a photograph like this was possible, a Fokker Tri-Motor airliner matches its speed with the New York Central Railroad's crack passenger train, the 20th Century Limited. (*Cleveland Press* Collection, CSU.)

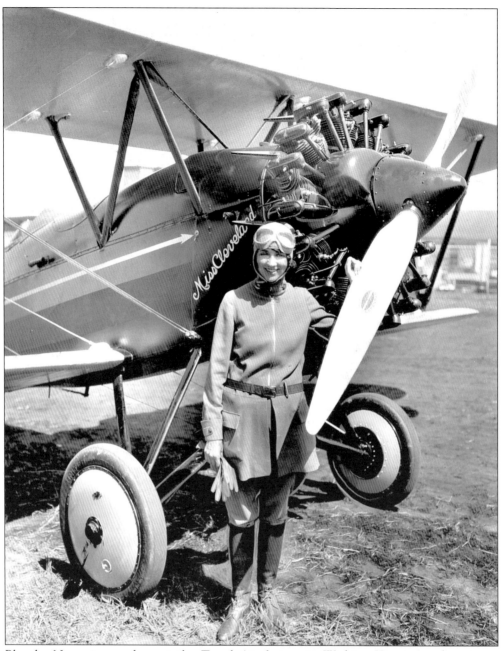

Blanche Noyes is seen here at the Travel Air factory in Wichita, Kansas, as she accepts delivery of the Travel Air Speedwing she flew in the 1929 Women's Air Derby. (*Cleveland Press* Collection, CSU.)

Ruth Nichols poses in the cockpit of the Rearwin Ken Royce biplane she flew in the 1929 Women's Air Derby. (*Cleveland Press* Collection, CSU.)

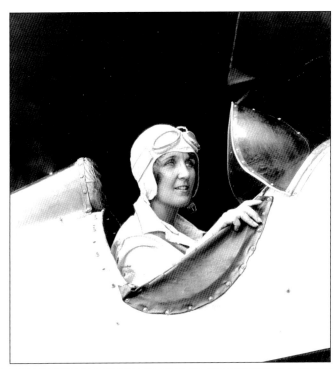

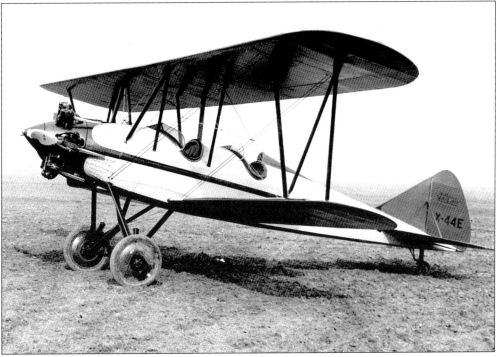

This Rearwin Ken Royce biplane is the aircraft Ruth Nichols flew in the 1929 Women's Air Derby. On the final day of the race, and practically within sight of the finish line in Cleveland, Nichols demolished the airplane in the course of an encounter with a steamroller while landing in Columbus, Ohio. (*Cleveland Press* Collection, CSU.)

Taken during a fuel stop in Terre Haute, Indiana, two contestants in the 1929 Women's Air Derby are seen waiting for the race to continue. The aircraft seen on the right is the Taperwing Waco flown by Gladys O'Donnell. To the left is the Fleet flown by Jessie Keith-Miller. (Courtesy of the International Women's Air and Space Museum.)

The bracelet pictured here was presented to each participant in the 1929 Women's Air Derby. (Courtesy of the International Women's Air and Space Museum.)

CLIFF. W. HENDERSON
MANAGING DIRECTOR

September 19, 1929

Miss Ruth Nichols
Rye, New York

Dear Miss Nochols:

Now that the intense glamor and activity of the races have passed it is a pleasant duty to make a summary of the results of the National Air Race project. This year's race included the introduction of many new activities. However, the participation of lady pilots in the first national air derby for women and their successful participation in closed course events were unquestionably outstanding features. If there ever was a question as to women's ability to fly and to take a significant part in this great industry it is now definitely and finally settled, and their important role in future development will be an accepted fact.

It is indeed a pleasure to express an appreciation on behalf of the Air Race Association as well as my personal gratitude for your participation in the races.

Under separate cover an air race bracelet is being forwarded to you, and it expresses in a small way the sincere gratitude of the Air Race group as well as the city of Cleveland as a whole. Possibly you will lay it away with the many other items of appreciation you have received. However, I trust it will always serve to remind you of the "great battle of Cleveland in the year 1929".

Although the event itself has passed into history the aviation critics declare it to be a significant milestone in the history of the industry, and you can justly retain a personal pride in having contributed so generously to the success of the "Air Classic of the Century".

Kindest personal regards –

Sincerely yours,

Cliff Henderson

This letter from Cliff Henderson explains the background on the bracelets given as mementos to all pilots who participated in the 1929 Women's Air Derby. (Courtesy of the International Women's Air and Space Museum.)

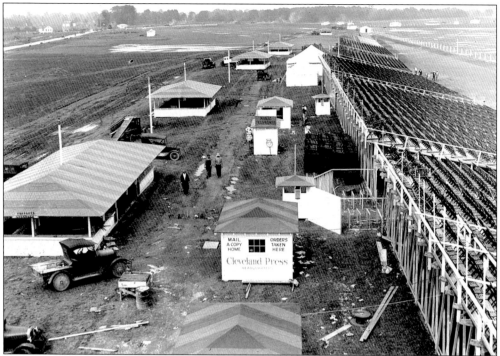

In the last week of August 1929, workers rush to complete the concession stands and other structures needed for the first presentation of the National Air Races in Cleveland. (*Cleveland Press* Collection, CSU.)

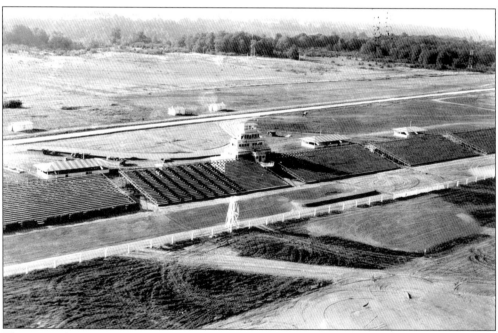

This view from August 1929 shows the newly constructed facilities built to accommodate spectators for the National Air Races in Cleveland. (*Cleveland Press* Collection, CSU.)

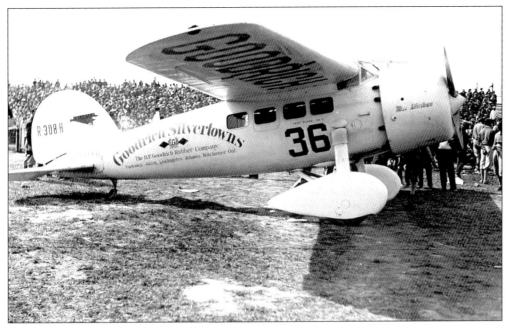

Flown by Lee Schoenhair, this Lockheed Vega placed second in the 1929 Non-Stop Air Derby, a cross-country race from California to Cleveland. The event was the direct predecessor of the Bendix Trophy Race, which was first held in 1931. (*Cleveland Press* Collection, CSU.)

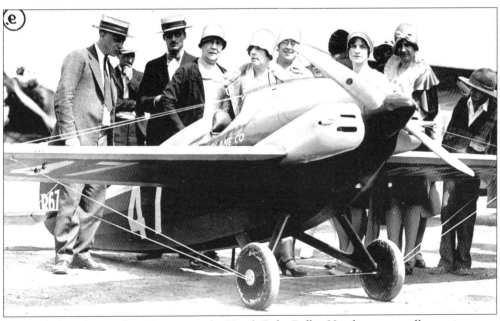

Ed Heath flew this airplane, known as the Heath *Baby Bullet*. Heath was a small man, just over five feet tall and weighing 110 pounds. The airplane was sized to fit him perfectly and is seen here as it appeared in 1929, painted maroon with silver trim. Powered by a 32-horsepower Bristol Cherub engine, it reportedly once attained a speed in excess of 150 miles per hour. (*Cleveland Press* Collection, CSU.)

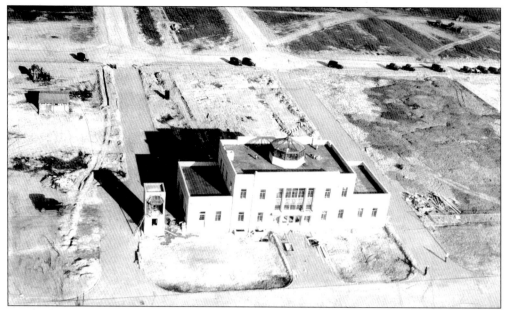

Taken in August 1929, this image shows the Cleveland airport's new administration building. One of the airport's focal points for more than 25 years, it was destroyed to make way for a new passenger concourse in the 1950s. (*Cleveland Press* Collection, CSU.)

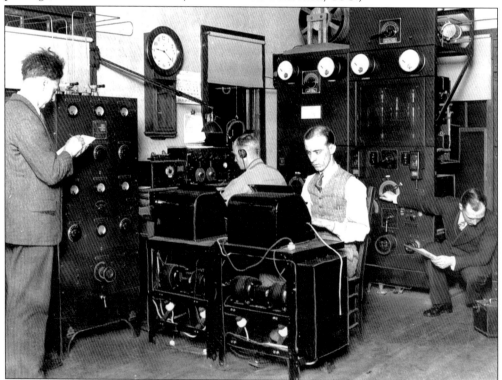

Taken in 1929, this view shows one of the earliest facilities of its type in the United States. Located in the airport administration building, this equipment made it possible to relay aviation weather reports to other cities and monitor early radio navigation beacons. (*Cleveland Press* Collection, CSU.)

Blanche Noyes waves from the cockpit of a Cleveland-built Great Lakes biplane sponsored by the city's Halle Brothers Department Store. Since Noyes herself was a Cleveland native, this photograph could not have a much stronger association with the city. (*Cleveland Press* Collection, CSU.)

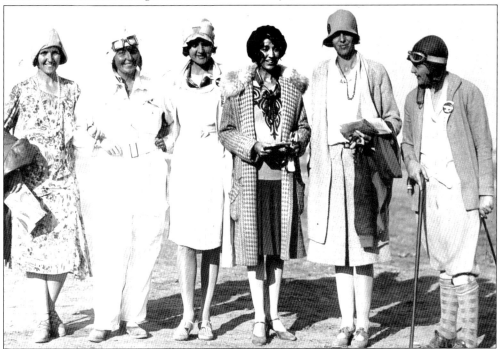

These women took part in the 1929 Women's Air Derby. From left to right, they are Ruth Nichols, Thea Raasche, Gladys O'Donnell, Blanche Noyes, Amelia Earhart, and Phoebe Omlie. (*Cleveland Press* Collection, CSU.)

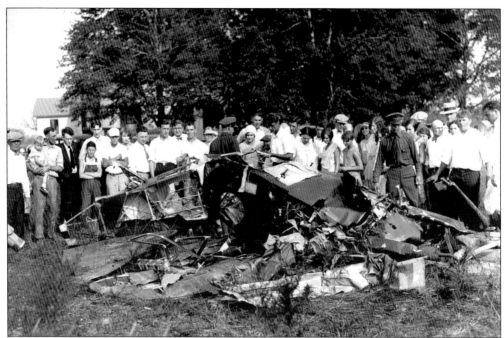

This photograph documents one of the closest calls Jimmy Doolittle ever had in an airplane. While practicing an aerobatic routine for the 1929 National Air Races, the wings of his Curtiss Hawk folded. He barely escaped with his parachute and landed heavily on two recently healed broken ankles. He returned to the airport, borrowed another airplane, and presented his routine as if nothing had happened. Here curious onlookers gather to look at the wreck of his airplane where it landed on a farm in Olmsted Falls, Ohio. (*Cleveland Press* Collection, CSU.)

This Stearman C3B was photographed in July 1929. Its fabric covering, external wire bracing, fixed landing gear, and uncowled radial engine were common features that year. The typical American light plane would look very different 10 years later. (*Cleveland Press* Collection, CSU.)

Three

THE 1930s

This decade is rightly remembered as air racing's golden age. The personalities gathered in Cleveland, and the aircraft they designed and flew have become legends.

Private individuals using their own resources and imaginations routinely built and flew airplanes that handily outperformed contemporary military airplanes, and the results of this friendly competition meant that the aviation technology needed to win the Second World War would be available when the crisis came. The prewar races ended in September 1939 with the beginning of the war in Europe. The spectators and competitors left for home having no way of knowing if or when the National Air Races would ever resume.

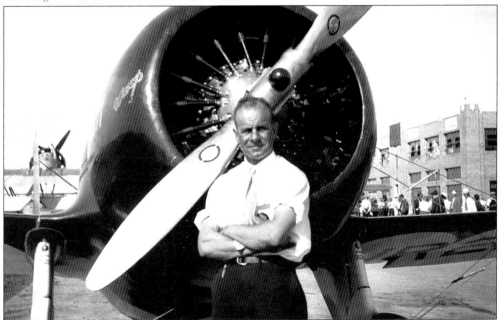

Knowing when to quit, Jimmy Doolittle won the Thompson Trophy and announced his retirement from air racing. Taken late in the afternoon of September 5, 1932, this photograph shows one of America's greatest racing pilots at the pinnacle of his career. (Courtesy of Bernadine Crozier.)

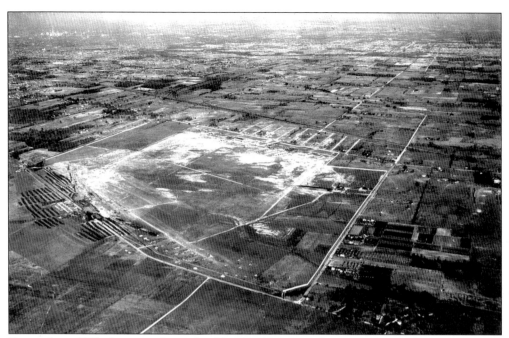

Dating from 1935, this view shows the Cleveland Municipal Airport during the heyday of the National Air Races. On the left may be seen the bleachers and the parking area. On the right is the Ohio National Guard hangar. In the middle distance, the administration building and hangars are visible. Also note the temporary fence around the airport to block the view of unpaid spectators. (*Cleveland Press* Collection, CSU.)

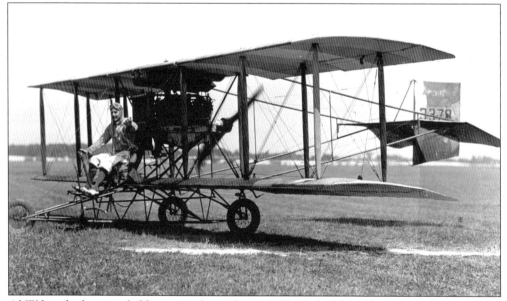

Al Wilson had a remarkable résumé for a pilot in 1932. He had been flying actively since 1913. This photograph was taken moments before his last flight. After a mock dogfight with an autogiro, Wilson's Curtiss Pusher replica somehow collided with the autogiro as the aircraft maneuvered to land. Wilson plummeted to the ground in front of the grandstands from a height of 100 feet. (*Cleveland Press* Collection, CSU.)

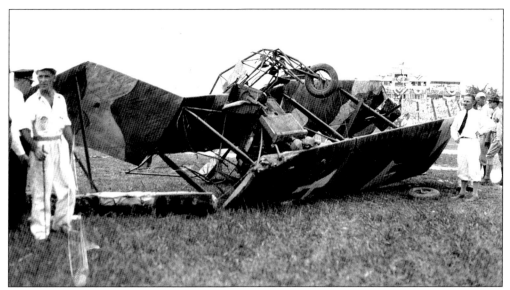

This image shows the wreck of Al Wilson's Curtiss Pusher replica as it looked in the aftermath of his deadly midair collision with the autogiro flown by Johnny Miller. Initially pinned beneath this wreckage, Wilson was transported to a hospital in nearby Berea, Ohio, where he died a short time later. Wilson's brother, Roy, also a well-known movie stunt pilot, was killed just two months earlier when he failed to recover from a dive during what should have been a routine stunt. (*Cleveland Press* Collection, CSU.)

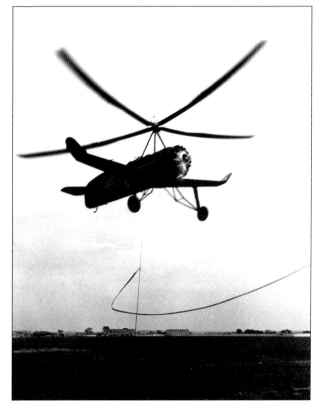

Johnny Miller demonstrates the unique capabilities of his autogiro to the crowd at the 1932 National Air Races. (*Cleveland Press* Collection, CSU.)

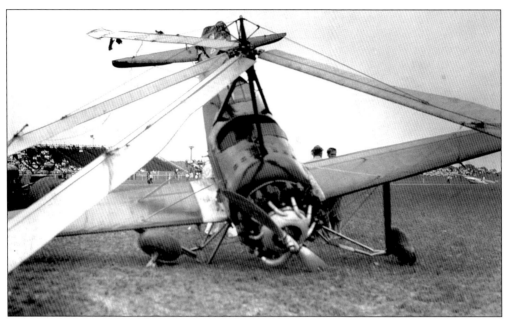

This image illustrates the damage sustained by Johnny Miller's autogiro as a result of the midair collision with the Curtiss Pusher replica flown by Al Wilson. While Wilson's injuries were fatal, Miller and his passenger, a *Cleveland Press* reporter, walked away. (*Cleveland Press* Collection, CSU.)

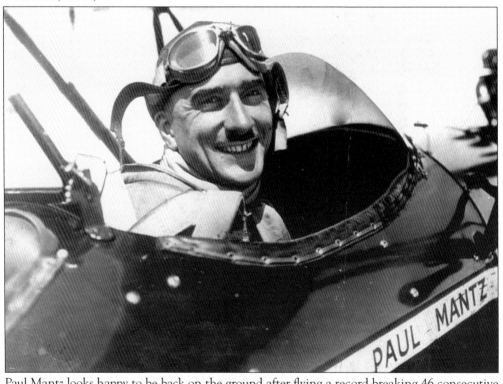

Paul Mantz looks happy to be back on the ground after flying a record-breaking 46 consecutive outside loops, July 9, 1930. (*Cleveland Press* Collection, CSU.)

Two of air racing's immortals, Jimmy Doolittle and the Gee Bee R-1, are seen here at the moment of their victory in the 1932 Thompson Trophy Race. (*Cleveland Press* Collection, CSU.)

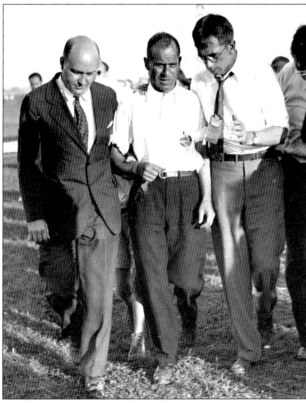

Shortly after the race ended, and looking slightly the worse for wear, 1932 Thompson Trophy winner Jimmy Doolittle is escorted to the winner's circle to receive his trophy. (*Cleveland Press* Collection, CSU.)

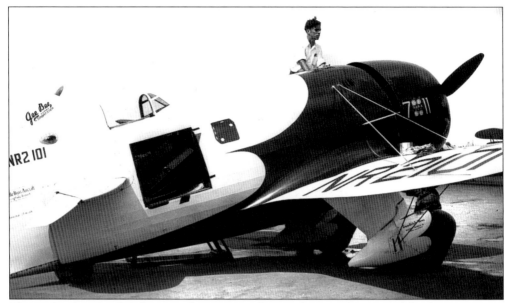

This is the Gee Bee R-2 flown in the 1932 Bendix Trophy Race by Lee Gehlbach. A native of Mount Clemens, Michigan, Gehlbach was a substitute for scheduled pilot Russell Boardman, who was badly injured in a crash shortly before the race. During the Bendix Trophy Race, this airplane suffered a serious oil leak. Rather than submit to repairs that would have put him out of the race, Gehlbach topped off his oil tank and continued. With the airplane literally covered with oil, he reached Cleveland in time to claim fourth place. (Courtesy of Bernadine Crozier.)

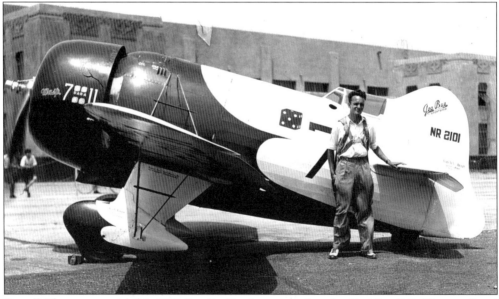

Russell Thaw poses with his 1933 Bendix Trophy contender, the Gee Bee R-2. Thaw suffered a landing mishap during a fuel stop in Indianapolis. After witnessing Russell Boardman's fatal crash there in the Gee Bee R-1, Thaw chose not to continue the race. A short time later, while flown by Jimmy Haizlip, an ill-advised sideslip led to the R-2's destruction in a landing accident. This photograph was taken at Roosevelt Field, Long Island, New York. (*Cleveland Press* Collection, CSU.)

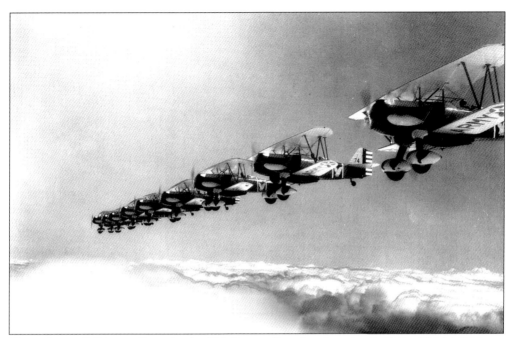

These Curtiss P6Es were flown by the 17th Pursuit Squadron based at Selfridge Field, Michigan. A group of airplanes from this unit visited Cleveland during the 1932 National Air Races. (*Cleveland Press* Collection, CSU.)

A long way from the Western Front, 62-victory ace and holder of the Ordre Pour le Mérite, Ernst Udet watches the National Air Races with an unidentified friend. (*Cleveland Press* Collection, CSU.)

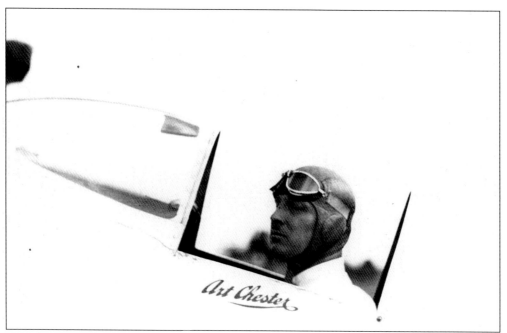

Art Chester began racing in the late 1920s, flying stock aircraft in a variety of races. By 1933, he was flying capable airplanes of his own design. He was a fierce competitor in the prewar races and cut quite a figure when he arrived at events driving an Auburn boat-tailed speedster painted to match his racing planes. Returning to racing after World War II, Chester served as president of the Professional Race Pilots Association. Chester died in a crash while racing in San Diego in 1949. (Photograph by Joe Binder.)

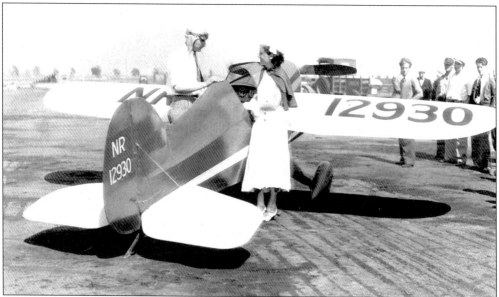

Art Chester designed this airplane and built it himself. Known as *Jeep*, it was powered by a four-cylinder Menasco engine rated at 185 horsepower. Competing in 1933, the airplane attained a top speed of 190 miles per hour. In this photograph, Chester discusses his racing prospects with an interested spectator, Dorothy Tree. (*Cleveland Press* Collection, CSU.)

Taken August 30, 1939, this photograph shows Art Chester's wife and son inspecting the instrument panel of his racer *Goon*. (Photograph by Fred Bottomer, *Cleveland Press* Collection, CSU.)

This photograph shows Art Chester's *Goon* as it appeared in Cleveland in 1939. Powered by a Menasco C6S4 of 290 horsepower, the airplane was a serious competitor. Chester defeated his rival, Tony LeVier, in that year's Greve Trophy Race, collecting $9,000 in prize money in the process. His airplane may be seen today in the Crawford Auto-Aviation Museum in Cleveland. (Photograph by John Nash, *Cleveland Press* Collection, CSU.)

One of the most notable racing pilots of the 1930s, and for long afterward, Steve Wittman poses here with *Bonzo*, the Curtiss D-12–powered racer he flew for several years in the late 1930s. (Photograph by Joe Binder.)

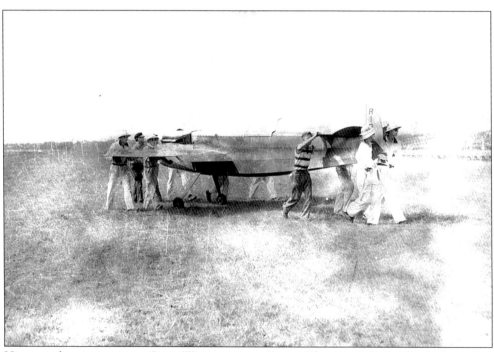

His ground crew repositions Steve Wittman's racer *Bonzo*. (Photograph by Joe Binder.)

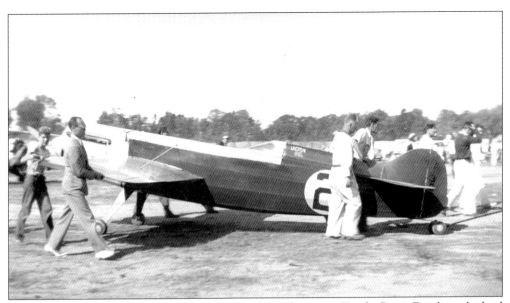

Steve Wittman flew this version of *Bonzo* in the 1937 Thompson Trophy Race. Firmly in the lead for 17 laps, Wittman was forced to throttle back by an oil leak. Rudy Kling won the race in his Folkerts Special. (*Cleveland Press* Collection, CSU.)

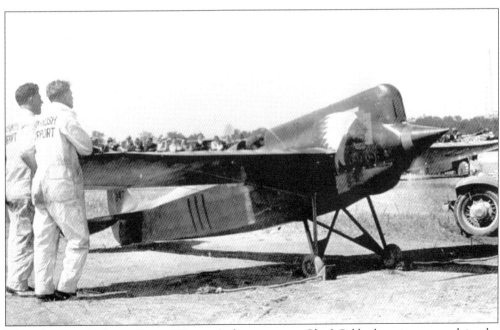

This photograph shows Steve Wittman's famous racer *Chief Oshkosh* as it appeared in the Nationals in Cleveland in 1931. Here Wittman performs an engine run-up with assistance from mechanics from his home field. (*Cleveland Press* Collection, CSU.)

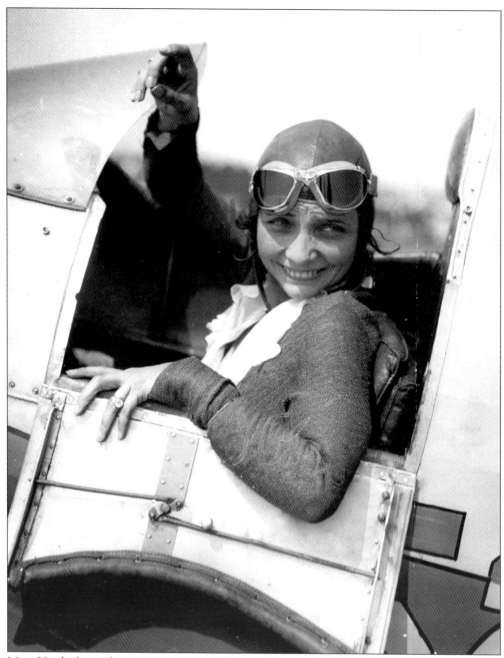

Mary Haizlip began her career as a racing pilot in 1929. Nearly always finishing in the money, she set a 300-mile-per-hour speed record in 1932 that stood for seven years. She became a test pilot and flew a Buhl Pup aircraft to an altitude of 35,000 feet. A very successful California realtor in later years, Mary Haizlip died in 1997 at age 87, one of the final surviving pilots from air racing's golden age. (*Cleveland Press* Collection, CSU.)

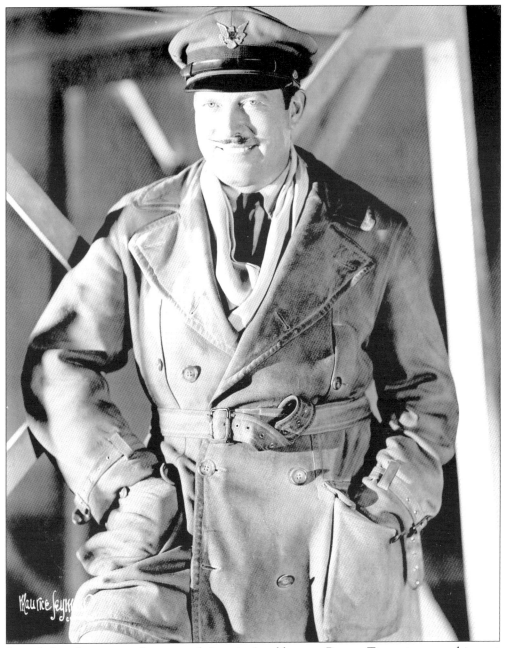

Regarded as the greatest showman of air racing's golden age, Roscoe Turner is seen at his most flamboyant in this picture from 1935. (*Cleveland Press* Collection, CSU.)

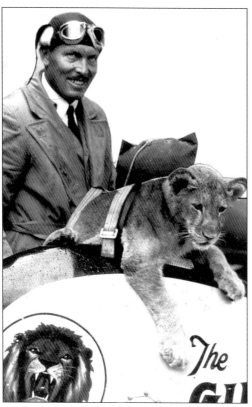

Roscoe Turner poses with perhaps the best marketing tool he ever devised, Gilmore, the lion cub. (*Cleveland Press* Collection, CSU.)

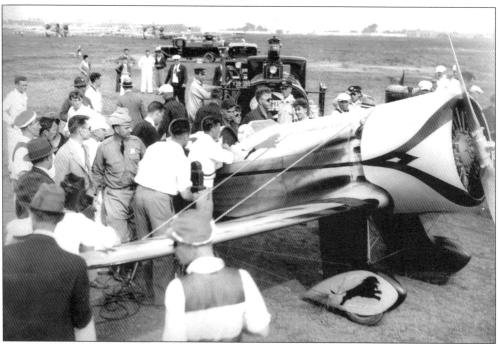

Showing signs of recent hard use, Roscoe Turner's Wedell-Williams racer displays its original paint scheme in this photograph taken at Cleveland in 1932. (*Cleveland Press* Collection, CSU.)

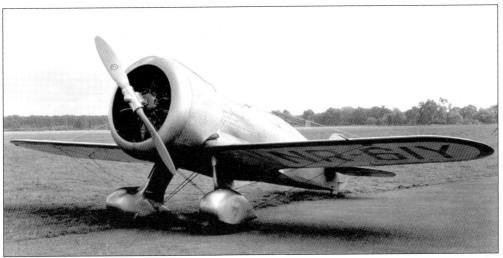

His Wedell-Williams racer really gave Roscoe Turner his money's worth in the 1930s. The airplane is seen here in the colors it wore for the 1933 air-racing season. The wings remain in their colors from the previous year, while the fuselage scheme reflects new corporate sponsors. The airplane still exists and may be seen today in Cleveland's Crawford Auto-Aviation Museum. (*Cleveland Press* Collection, CSU.)

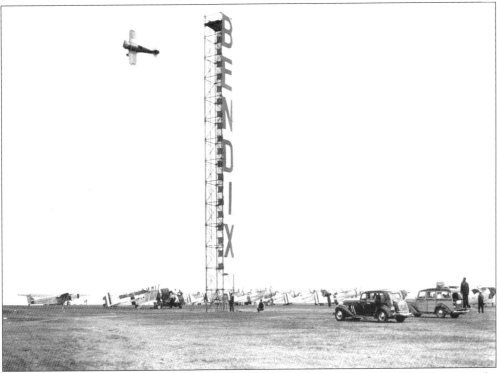

Roscoe Turner rounds a pylon in his Wedell-Williams racer during the 1935 Thompson Trophy Race. Shortly after this picture was taken, Turner experienced a total engine failure and made a dramatic forced landing directly in front of the grandstands. He walked away, and the airplane flew again. It may be seen today in Cleveland's Crawford Auto-Aviation Museum. (Photograph by Joe Binder.)

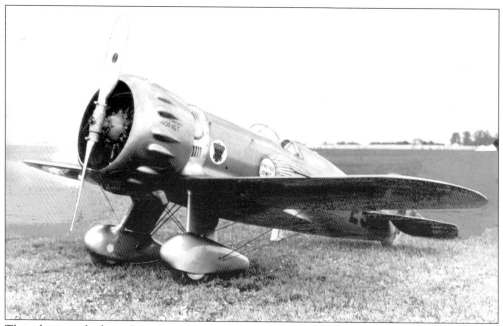

This photograph shows Roscoe Turner's often repainted Wedell-Williams in the final years of its active racing career when it was flown by Joe Mackey. The picture was taken at Cleveland in 1938. (*Cleveland Press* Collection, CSU.)

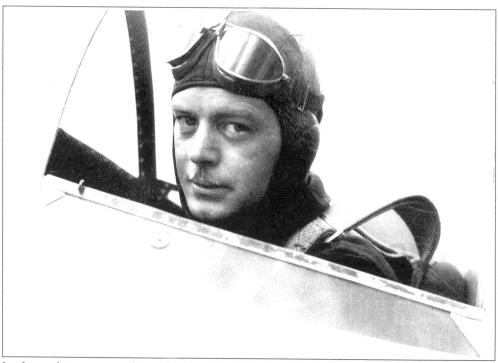

Looking a bit preoccupied, Joe Mackey glances outside the cockpit for a photograph. His aircraft is the Wedell-Williams formerly flown by Roscoe Turner. (Photograph by Joe Binder.)

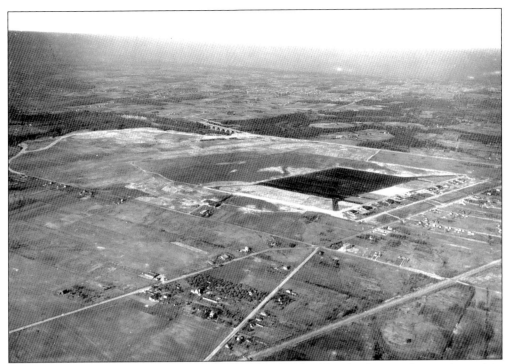

Taken in the autumn of 1936, this picture emphasizes the Cleveland airport's vast size and its essentially rural surroundings. (*Cleveland Press* Collection, CSU.)

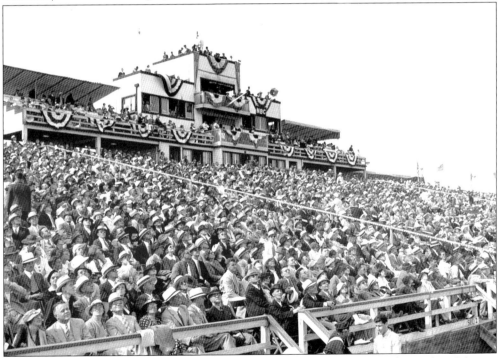

A prosperous crowd watches the 1935 National Air Races. The view shows the elaborate permanent structures the air races made necessary. (*Cleveland Press* Collection, CSU.)

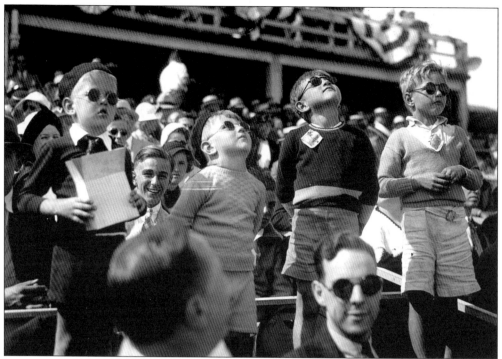

Ignoring the photographer, these boys are determined not to miss any of the action on Labor Day 1935. (*Cleveland Press* Collection, CSU.)

Benny Howard's racers *Ike* and *Mike* were nearly identical. This view of *Ike* was taken in Cleveland in 1935 and emphasizes the racer's narrow fuselage and steep ground angle. *Ike* survives today, one of the very few golden age racers to remain in private hands. (Photograph by Joe Binder.)

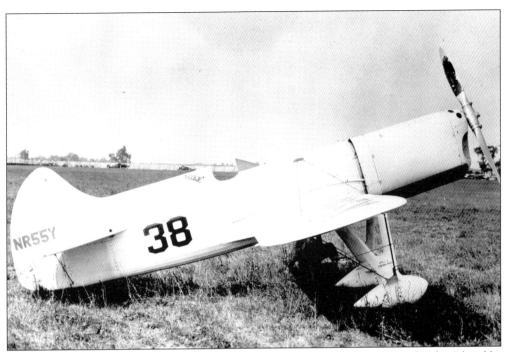

Race No. 38 was *Mike*, the second Howard racer in the pair that made up *Ike* and *Mike*. Piloted by Harold Neumann, *Mike* won the Greve Trophy in 1935, the year Howard aircraft swept the National Air Races, winning the Bendix, Thompson, and Greve Trophies. (Photograph by Joe Binder.)

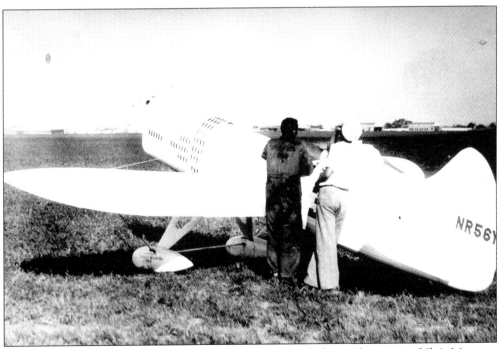

Benny Howard, right, and an unidentified assistant check the performance of *Ike*'s Menasco engine during the 1935 National Air Races in Cleveland. (Photograph by Joe Binder.)

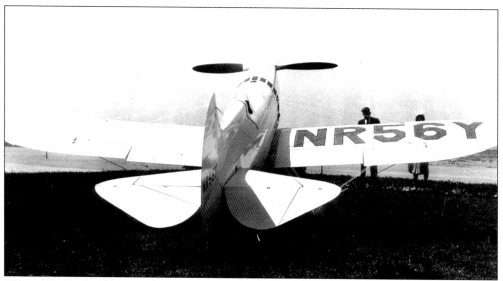

This view of the Howard racer *Ike* emphasizes the narrow fuselage and the high thrust line provided by the Menasco engine. The airplane was white. The registration number was gold with black edging. The picture was taken in 1935, the year of the so-called Benny Howard National Air Races. (Photograph by Joe Binder.)

This view of Benny Howard's racer *Ike* clearly illustrates the low frontal area made possible by the use of inverted in-line Menasco engines. (Photograph by Joe Binder.)

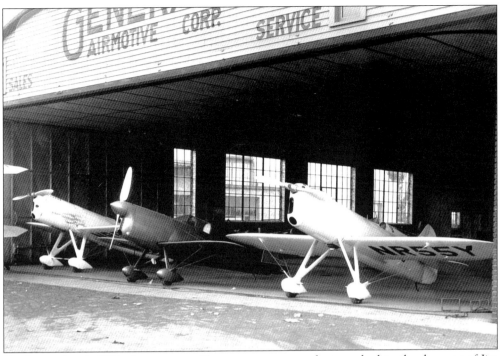

On September 1, 1934, three great golden age racers were photographed in the doorway of Jim Borton's General Airmotive hangar at the Cleveland airport. From left to right, they are Benny Howard's *Ike*, the Miles and Atwood Special, and Howard's *Mike*. The Miles and Atwood racer was destroyed in a fatal crash at Cleveland 1937. *Ike* and *Mike* survive today. (Joe Binder Collection.)

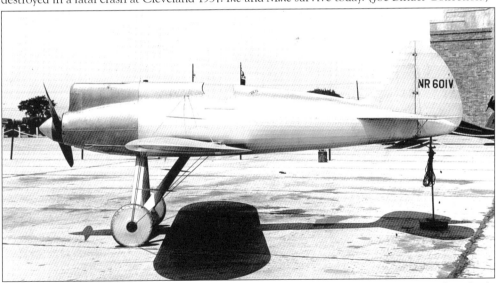

Benny Howard's DGA-3, known as *Pete*, was constructed in 1930 and campaigned tirelessly until 1935. Flown by Joe Jacobson in the later stages of its prewar career, it continued to place in the money even though outclassed by newer racers. *Pete* resurfaced as a Goodyear racer in 1947. Eventually converted to a home-built, components of the original racer have been incorporated in a re-creation currently displayed at Cleveland's Crawford Auto-Aviation Museum. (*Cleveland Press* Collection, CSU.)

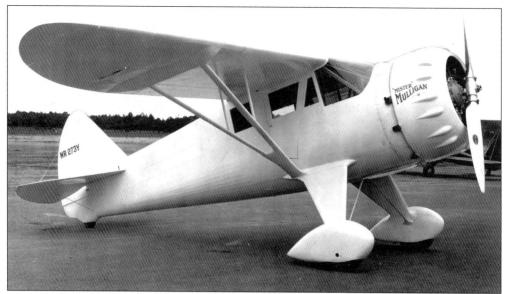

"Mister" Mulligan's appearance was very conventional for a 1930s Thompson Trophy racer. This sound design formed the basis for several very highly regarded Howard aircraft constructed for years afterward. (*Cleveland Press* Collection, CSU.)

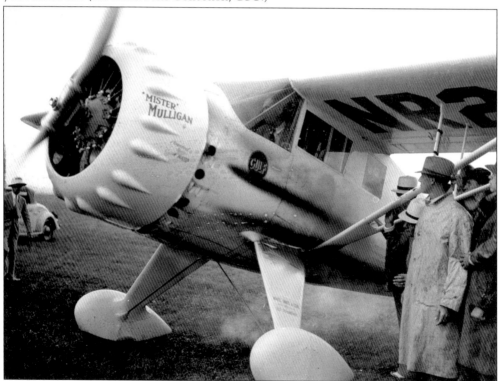

In a driving rain, and with Benny Howard visible in the left seat, "*Mister*" *Mulligan* taxies to a halt at the Cleveland airport at the end of the 1935 Bendix Trophy Race. When elapsed times were calculated, Howard and his friend Gordon Israel found that they had won the cross-country race by a margin of 24 seconds. (*Cleveland Press* Collection, CSU.)

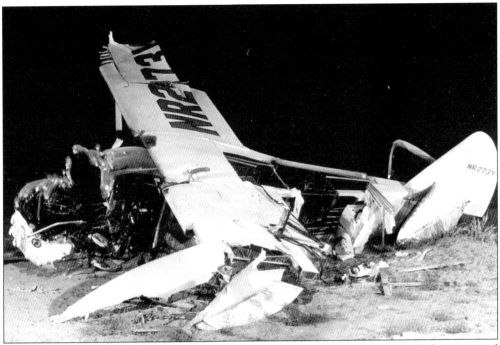

The battered remains of *"Mister" Mulligan* are seen here shortly after the crash that occurred during the 1936 Bendix Trophy Race. Flown by Benny and Maxine Howard, the aircraft lost a propeller blade, causing a forced landing in very inhospitable terrain. The Howards survived with serious injuries. (*Cleveland Press* Collection, CSU.)

Months after their disastrous crash in the 1936 Bendix Trophy Race, Benny and Maxine Howard smile bravely despite the effects of the serious multiple injuries from which they were still recovering. (Photograph by James Meli, *Cleveland Press* Collection, CSU.)

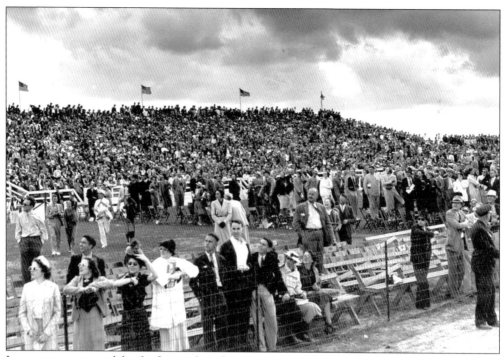

It was not a very good day for flying when this picture was taken in Cleveland in 1937. (*Cleveland Press* Collection, CSU.)

Taken in front of Jim Borton's General Airmotive hangar during the 1935 Nationals, this view of the Loose racer gives a sense of the pilot's perspective from the cockpit. (*Cleveland Press* Collection, CSU.)

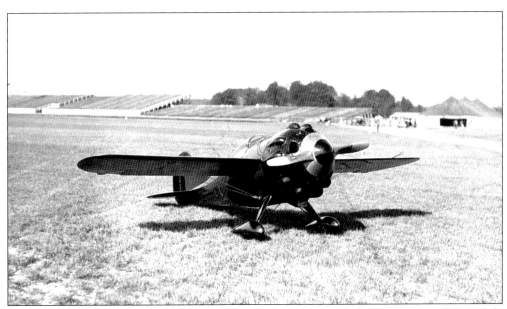

Named for its designer, Chester Loose, the Loose racer appeared in Cleveland in 1937. While its design and construction reflected great imagination and skill, it did not participate in the races that year because no events were scheduled for aircraft with engines in its power range. (Photograph by Joe Binder.)

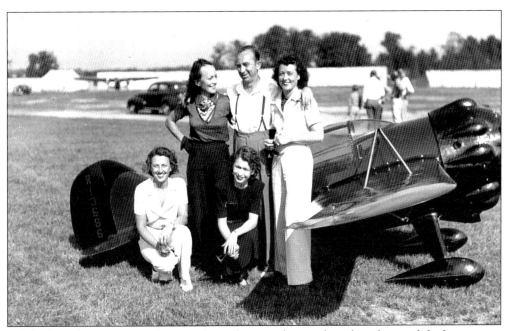

While their identities are unfortunately not known, the people gathered around the Loose racer emphasize its small size. It is said to have been the smallest airplane ever built to participate in the National Air Races. (Photograph by Joe Binder.)

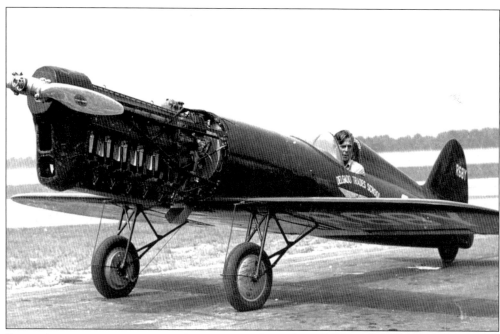

Bryan Armstrong, an aeronautical engineer and member of the staff at the Delgado Trades School in New Orleans, Louisiana, designed this racer, which was constructed by students studying there. Known as the *Delgado Flash*, it certainly looked fast sitting on the ground but failed to perform well in the air. In what must have been a great disappointment to the boys who constructed it, it was forced to drop out of both events in which it was entered. Undaunted, they took it back to New Orleans, determined to improve it and return the following year, which they did. The improvements were to no avail, and the airplane was eventually stored in a warehouse. It was destroyed when fire consumed the building several years later. (Photograph by Joe Binder.)

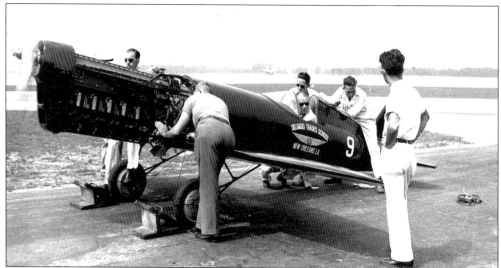

A ground crewman straddles the rear fuselage of the *Delgado Flash* to prevent a prop strike during a ground test of its super-charged Menasco Super Buccaneer engine. (Photograph by Joe Binder.)

48

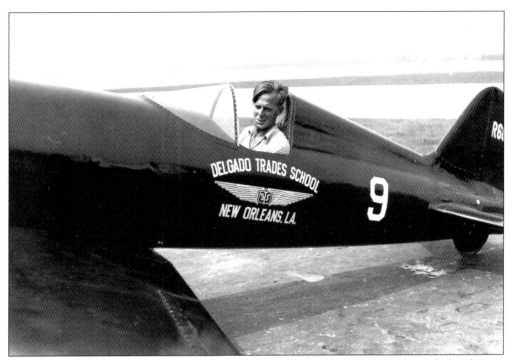

Clarence McArthur was the pilot who conducted the test flights of this one-of-a-kind racer constructed by students at the Delgado Trades School in New Orleans. (Photograph by Joe Binder.)

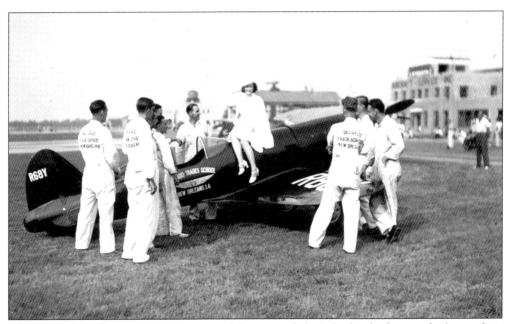

The boys who built it do not seem to mind the young lady in heels who has perched atop their airplane to pose for her photograph. (Photograph by Joe Binder.)

Frank Haines poses with his racer during the 1937 National Air Races. Its Keith Rider ancestry is obvious. While the airplane was impressive, it failed to live up to its promise and was not destined to last much longer. Haines died in a crash at the scatter pylon in a December 1937 air race in Miami the same day 1937 Thompson Trophy winner Rudy Kling lost his life. (Photograph by Joe Binder.)

Frank Haines poses with his racer on the ramp at Cleveland with a line boy and a fuel truck in the background. (Photograph by Joe Binder.)

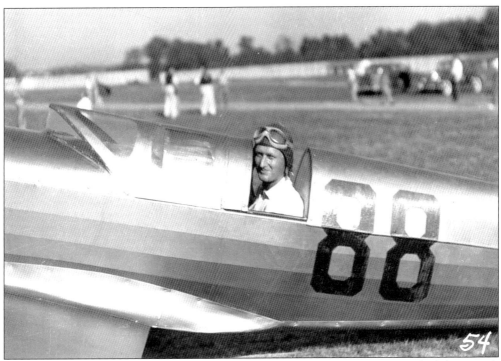

This is a portrait of Frank Haines and his ill-fated racer taken at the 1937 Nationals. (Photograph by Joe Binder.)

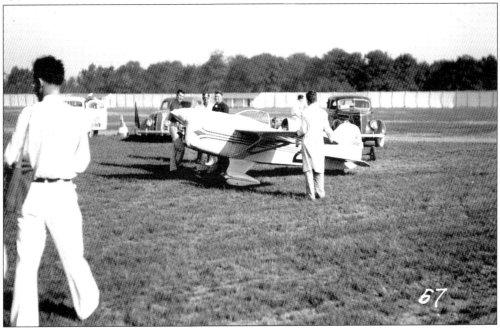

Taken in 1937, this photograph shows Art Chester preparing for a flight in his well-known racer *Jeep*. Powered by a Menasco engine of 185 horsepower, this racer was a common sight in the 1930s. The aircraft survives today in the collection of the Experimental Aircraft Association. (Photograph by Joe Binder.)

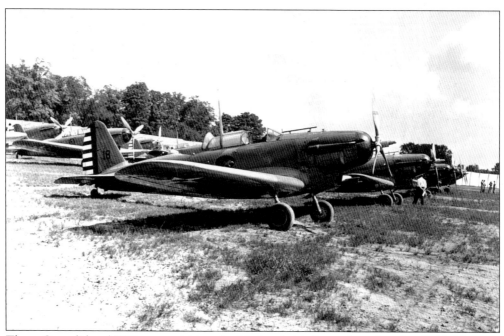

These Consolidated P-30s were visiting the National Air Races from Langley Field, Virginia, when this picture was taken at Cleveland in 1937. The aircraft were assigned to the 9th Pursuit Squadron. (Photograph by James Thomas, *Cleveland Press* Collection, CSU.)

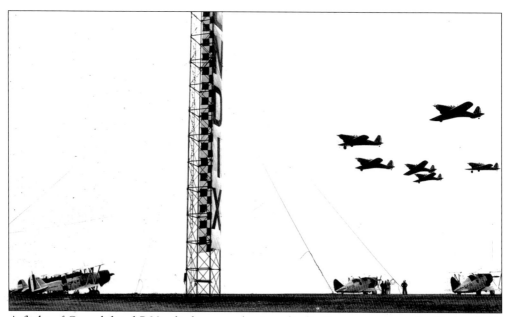

A flight of Consolidated P-30s climbs out to begin a display for spectators at the National Air Races in Cleveland in 1937. The airplanes parked on the ground directly beneath them are Marine Corps Grumman F3F-2s, the last biplane fighters the Marines flew. (Photograph by Joe Binder.)

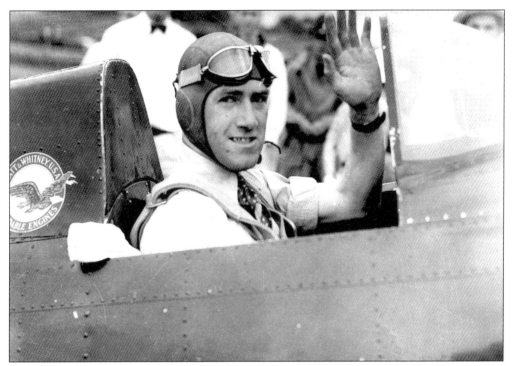

Earl Ortman waves to onlookers from the cockpit of his Marcoux-Bromberg racer. The photograph was taken in 1937, and the airplane it depicts may be seen today in the New England Air Museum in Windsor Locks, Connecticut. (Photograph by Joe Binder.)

Earl Ortman rounds a pylon in the 1937 Thompson Trophy Race. The aircraft is a Marcoux-Bromberg racer. Ortman flew it to second place. (Photograph by Joe Binder.)

Obviously engrossed in their work, these mechanics are working hard to prepare the San Diego Flaggship F-15 to compete in the 1937 National Air Races. Designed by Claude Flagg, the aircraft was scheduled to be flown by Tony LeVier that year. Alex Papana's Bücker Jungmeister is visible in the background. (Photograph by Joe Binder.)

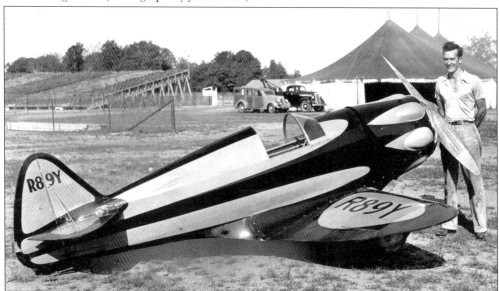

A young Tony LeVier poses with the Flagg racer he was scheduled to fly in the 1937 Nationals in Cleveland. Fitted with a new wing at the last minute, the airplane proved almost uncontrollable. It was badly damaged in the course of a takeoff. LeVier was lucky to walk away. Reworked for the following year, another pilot taxied the airplane into a rut left in soft ground by a fuel truck, ending its racing career. (*Cleveland Press* Collection, CSU.)

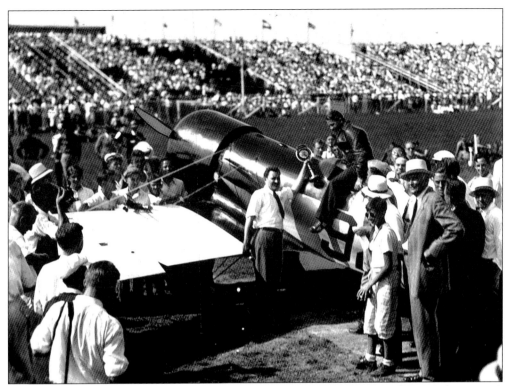

A radio announcer seeks a comment from Jimmy Haizlip as the weary pilot exits his aircraft in Cleveland after winning the 1932 Bendix Trophy Race. The airplane is a Wedell-Williams. (*Cleveland Press* Collection, CSU.)

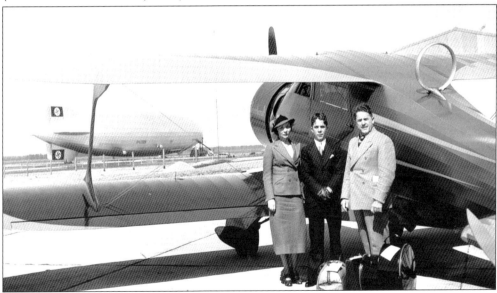

Jimmy and Mary Haizlip pose with their son, Jim Jr., shortly before departing for Europe aboard the Hindenburg, seen floating at its mooring mast behind them. Their Staggerwing Beech rode with them as freight in the airship. Jimmy Haizlip intended to use it for record-setting flights between European capitals. (*Cleveland Press* Collection, CSU.)

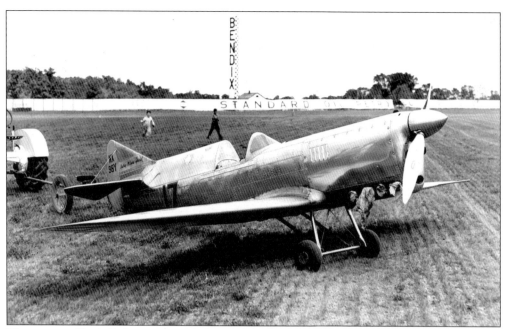

This veteran Keith Rider racer was known as the *Bushey-McGrew Special* when it posed for its picture at the Cleveland airport in 1938. Its pilot that year was George Dory of Los Angeles. (*Cleveland Press* Collection, CSU.)

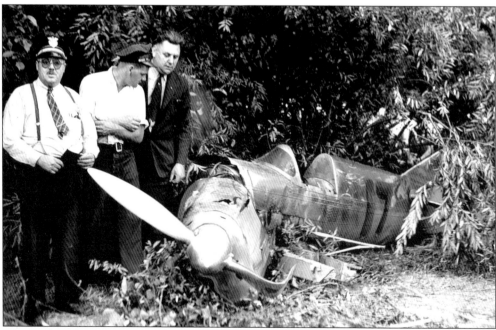

The Keith Rider R-2 met its end in the 1938 Nationals. In that year's Greve Trophy Race, the Menasco engine abruptly failed. With little altitude and few options, Dory extended his landing gear and attempted a forced landing on a street. Dory recovered after a lengthy hospital stay. The R-2 never flew again. (*Cleveland Press* Collection, CSU.)

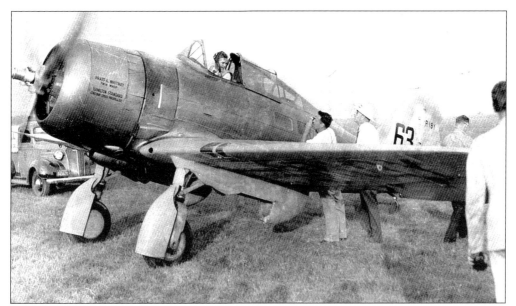

Engine running, strapped in, and ready to go, Frank Sinclair pauses long enough for one more photograph before taxiing out to participate in the 1937 Thompson Trophy Race. He placed fourth. His aircraft is a Seversky. (Photograph by Joe Binder.)

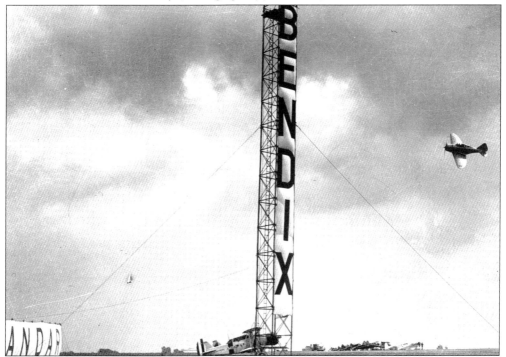

Frank Sinclair rounds a pylon in the 1937 Thompson Trophy Race. His Seversky is a rare example of a modified production aircraft appearing in this race in the 1930s. This photograph illustrates how low racing pilots routinely flew to be sure they did not miss a pylon. Sinclair finished the race in fourth place. The winner was Rudy Kling in his Folkerts SK-3. (Photograph by Joe Binder.)

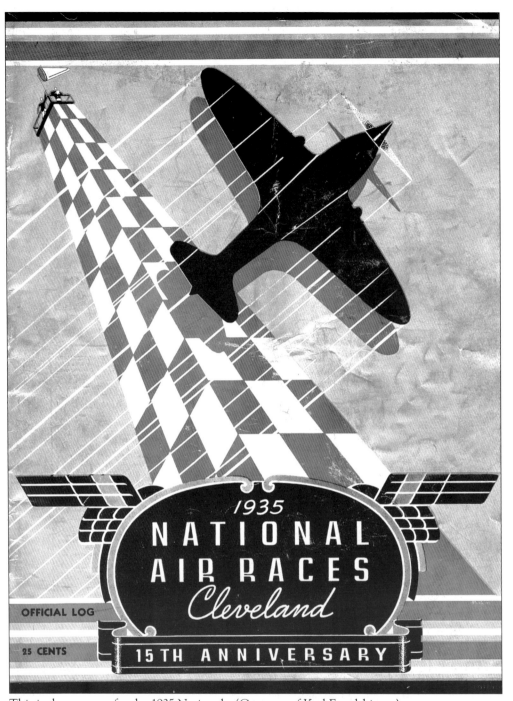

This is the program for the 1935 Nationals. (Courtesy of Karl Engelskirger.)

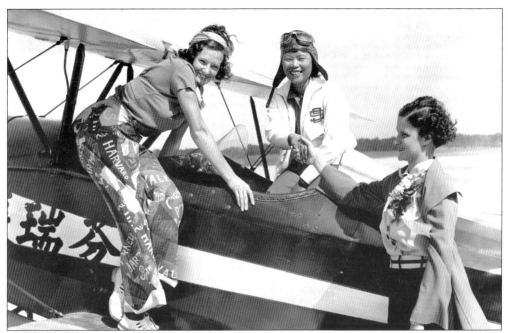

Taken in 1936, this view shows three participants in that year's Ruth Chatterton Air Derby, a cross-country race between Cleveland and Los Angeles. From left to right, they are Annette Gibson, Katherine Sui Fun Cheung, and Grace Prescott. The design on Cheung's jacket is the emblem of the Ninety-Nines, one of the first organizations for women pilots. (*Cleveland Press* Collection, CSU.)

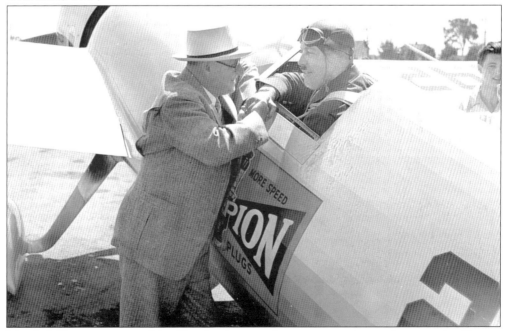

Maj. Jack Berry, manager of the Cleveland airport for many years, is seen here greeting Roscoe Turner as he arrived in Cleveland to participate in the 1939 National Air Races. (*Cleveland Press* Collection, CSU.)

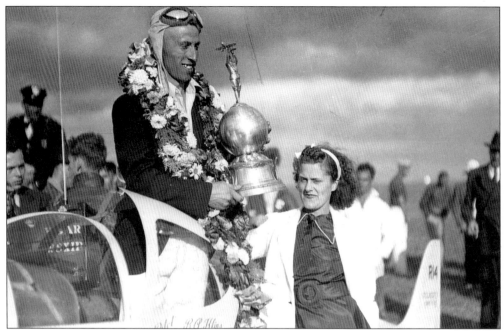

His wife joins him as a beaming Rudy Kling celebrates his victory in the 1937 Thompson Trophy Race. The aircraft is a Folkerts SK-3. On the left, a reporter from Cleveland radio station WGAR waits for an opportunity to get a comment from Kling. (Photograph by Joe Binder.)

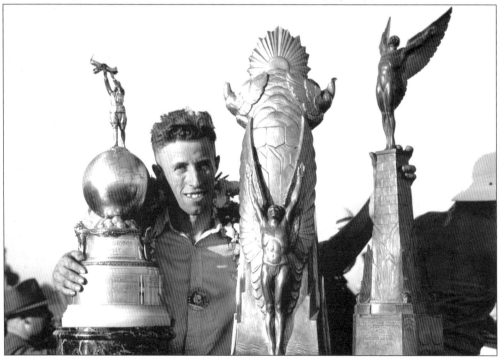

Rudy Kling out flew his competitors at the 1937 National Air Races to win the Greve, Thompson, and Henderson Trophies. He and his fame were destined to be short lived. On December 3, 1937, on his 29th birthday, Kling was killed in an air race in Miami. (*Cleveland Press* Collection, CSU.)

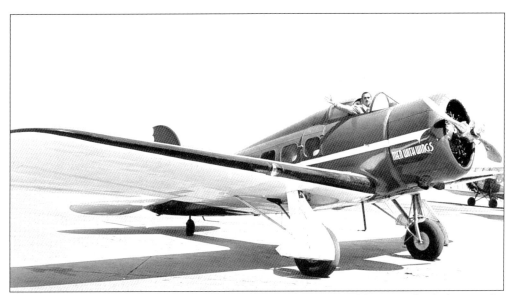

In 1938 and 1939, Paul Mantz flew the Lockheed Orion, pictured here, to third place in the Bendix Trophy Race. Previously flown as a corporate aircraft by Shell, Jimmy Doolittle was its pilot for several years. Mantz acquired the aircraft in St. Louis in 1938 and installed a supercharged Wright Cyclone of 750 horsepower. The airplane survives today in the Swiss Air Transport Museum in Lucerne, Switzerland. (*Cleveland Press* Collection, CSU.)

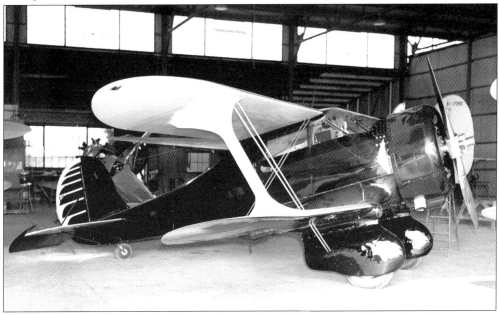

Constructed in May 1934, this Beechcraft Model A17F was one of the earliest Staggerwings built. Owned for a time by Howard Hughes, in 1937 this airplane was prepared to fly in the Bendix Trophy Race. Heavily loaded with long-range fuel tanks, the landing gear collapsed during takeoff. Pilot Bob Perlick escaped without injury. Back to try again a year later, Perlick was leading the race when engine failure resulted in a forced landing. Six years later, with less than 200 hours total time, this airplane was destroyed in a hangar fire. (*Cleveland Press* Collection, CSU.)

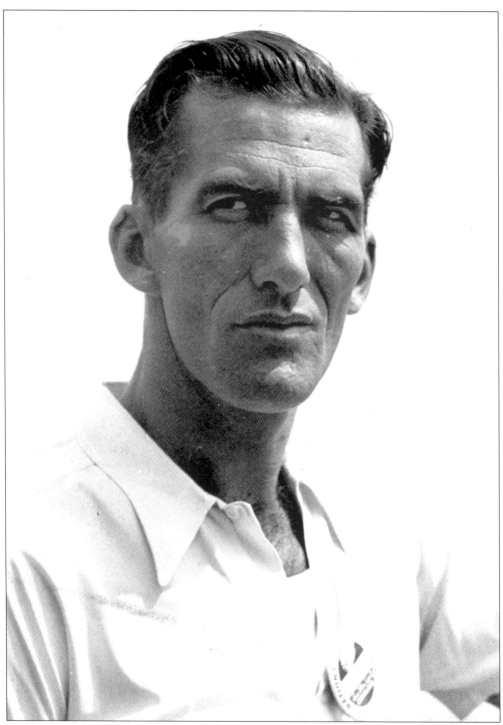

The grim expression on his face almost suggests that somehow Lee Miles knew what his fate was to be. During time trials for the 1937 Nationals, a fitting on a bracing wire failed under stress. His Miles and Atwood racer suffered a catastrophic in-flight structural failure, and Miles died in the resulting crash. (*Cleveland Press* Collection, CSU.)

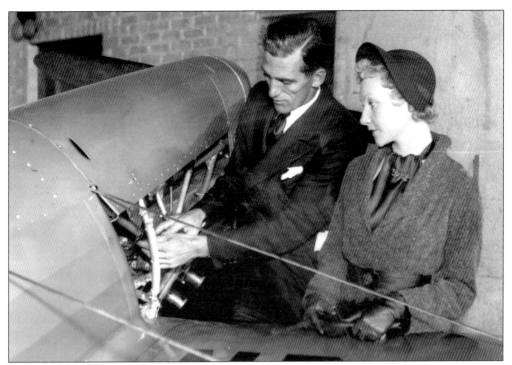

For the benefit of a photographer, Lee Miles pretends to make an adjustment to the Menasco engine of his Miles and Atwood racer as his wife looks on. (*Cleveland Press* Collection, CSU.)

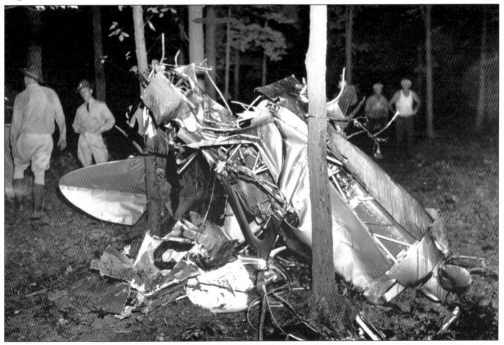

On September 3, 1937, pilot Lee Miles was killed when his Miles and Atwood racer suffered an in-flight structural failure. This is the crash site, located in heavy woods just northwest of the Cleveland airport. (*Cleveland Press* Collection, CSU.)

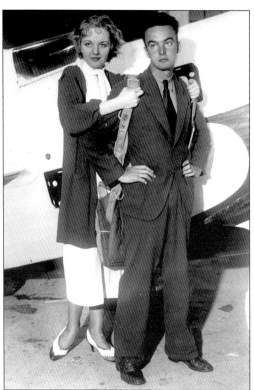

Not looking very happy about it, Russell Thaw submits to being helped into a parachute by actress Felice Carroll for this publicity shot taken on the eve of his participation in the 1933 Bendix Trophy Race. (*Cleveland Press* Collection, CSU.)

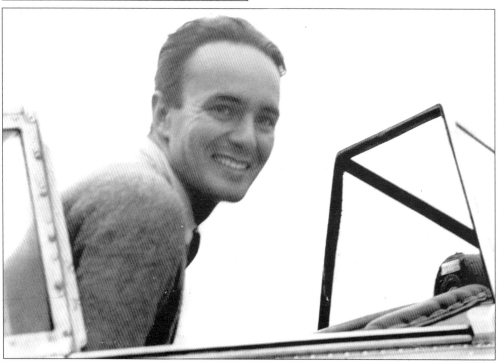

Thaw seems much more at ease in the cockpit of a Northrop Gamma shortly before the 1935 Bendix Trophy Race. (*Cleveland Press* Collection, CSU.)

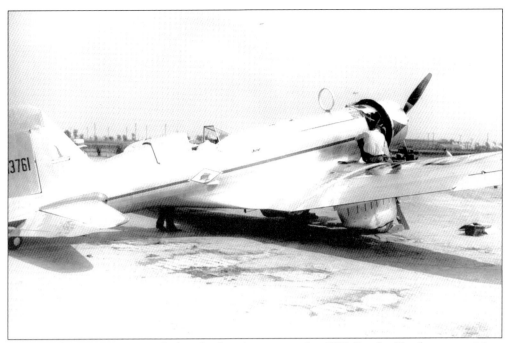

This Northrop Gamma was Jackie Cochran's entry in the 1935 Bendix Trophy competition. Forced down by bad weather, she was not able to complete the race. Later flown by Howard Hughes, this airplane went on to set a number of records. (*Cleveland Press* Collection, CSU.)

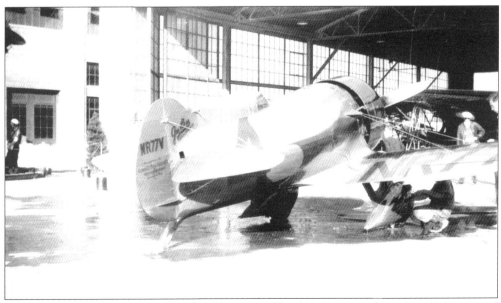

Clean racers flew faster. Here the 1931 Thompson Trophy winner is cleaned up by its ground crew. (Jim Young Collection.)

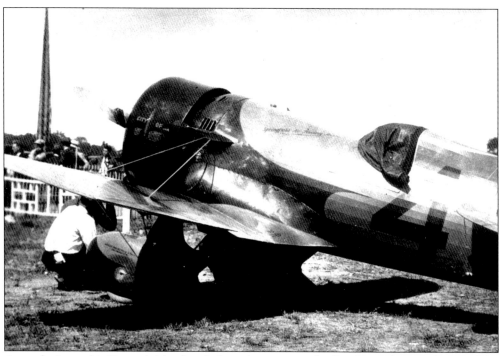

An early Army Air Corps A-1 leather flight jacket protects the Pryalin cockpit enclosure of the Gee Bee Model Z from the heat of the sun, Cleveland, 1931. (Jim Young Collection.)

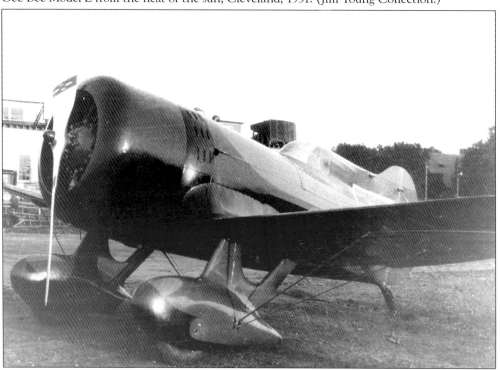

The Gee Bee Model Z was constructed in 1931. Flown by Lowell Bayles, it won the Thompson Trophy that year. (Jim Young Collection.)

Taken at the Granville Brothers factory at Springfield, Massachusetts, this is the Gee Bee Model Z. Visible just above the headrest fairing is the fuel cap later blamed as the cause of the crash that killed Lowell Bayles later in 1931. (Jim Young Collection.)

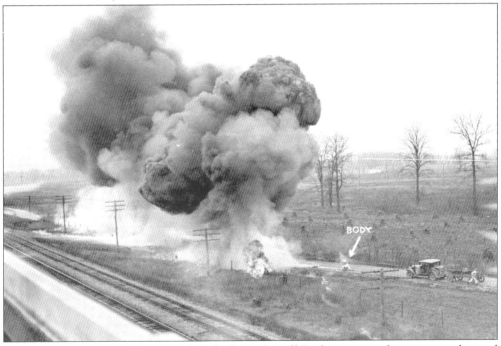

After winning the 1931 Thompson Trophy Race, Lowell Bayles attempted to set a speed record on December 7, 1931. As he descended to enter a measured course to attempt the record, it is theorized that a loose fuel cap struck the windscreen, stunning Bayles and causing an in-flight structural failure and the fatal crash shown here. (*Cleveland Press* Collection, CSU.)

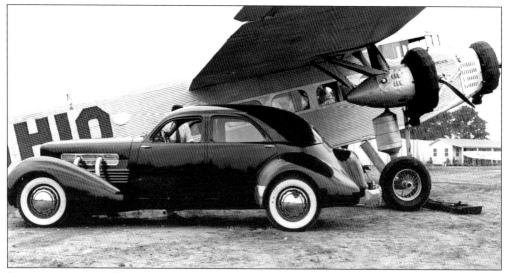

Sometimes it was difficult to say what was more impressive, the cars or the airplanes. One of the most desirable cars from its era, this Cord sedan is parked alongside a Ford Tri-motor sponsored by Standard Oil of Ohio. Incredibly, pilot Harold Johnson regularly flew an aerobatic display routine in this onetime commercial airliner. (Photograph by Joe Binder.)

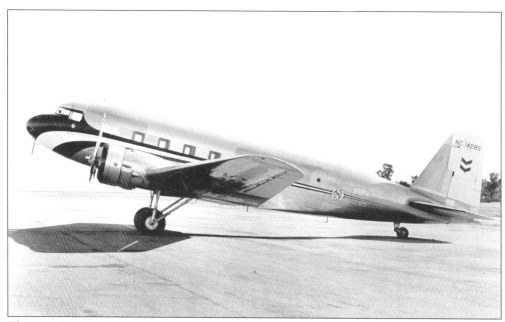

The very last word in modern air transportation when this picture was taken in 1934, this Douglas DC-2 shows many advanced design features derived directly from air racing. These features include its all-metal construction, low-wing monoplane design, retractable landing gear, and controllable pitch propellers. This aircraft was a company plane operated by Standard Oil of California. (*Cleveland Press* Collection, CSU.)

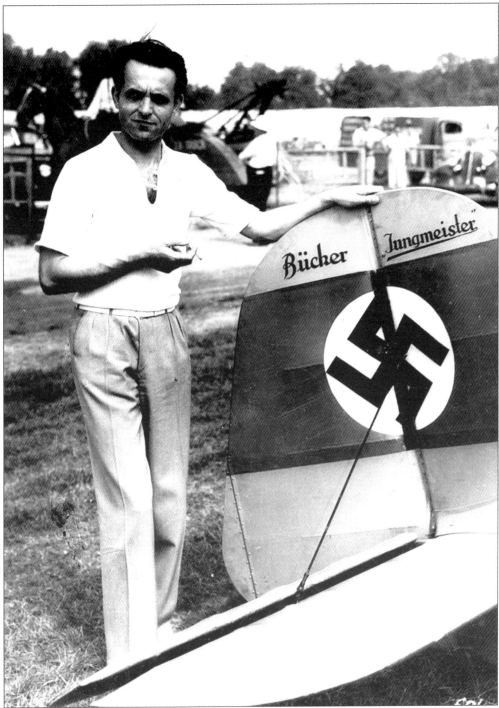

Otto von Hagenburg was a German pilot who became the world aerobatic champion in 1936. He poses here with the tail of his Bücker Jungmeister in Cleveland a year later. The red band, white disc, and swastika on the tail was a standard marking mandated for all German civil aircraft after the Nazis came into power. (Photograph by Joe Binder.)

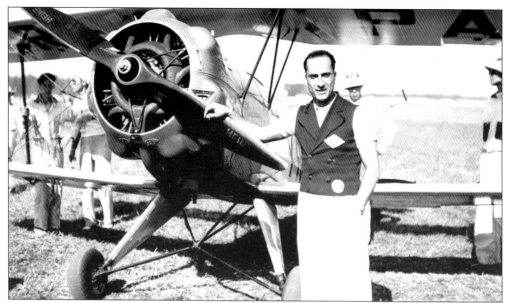

At the height of his success, Alex Papana poses for a portrait with his Bücker Jungmeister. A noted athlete who rode a bobsled in the 1932 Winter Olympics in Lake Placid, New York, Papana was one of the best-known aerobatic pilots in the world by the late 1930s. Unfortunately, his personal life would soon be clouded by tragedy. After giving birth to their daughter in 1938, his wife died. In 1945, he remarried, but distressed by difficulties in his second marriage, Alex Papana took his own life in April 1946. (Photograph by Joe Binder.)

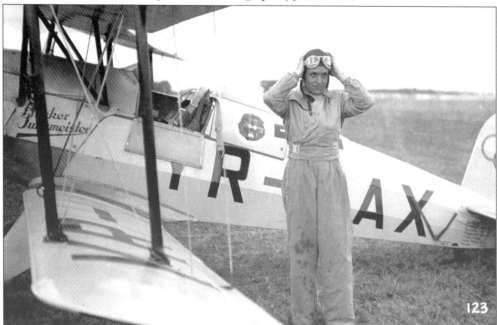

Another view of Papana with his Bücker Jungmeister is featured here. After he parted with his airplane, it passed through the hands of two renowned U.S. aerobatic pilots, Mike Murphy and Bevo Howard. Since the 1970s, the aircraft has been a part of the collection of the National Air and Space Museum. (Photograph by Joe Binder.)

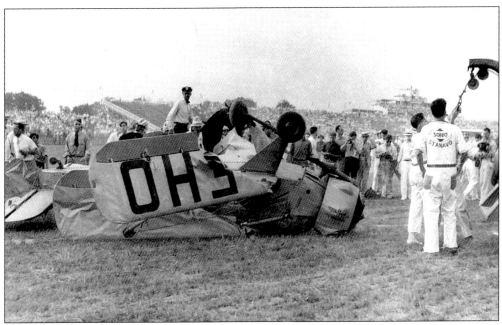

Otto von Hagenburg and Papana were rivals, and after seeing Papana execute an inverted low pass, Hagenburg tried to outdo him, with the result seen here. He walked away with minor injuries. In a display of great sportsmanship, Papana loaned his Jungmeister to Hagenburg so he could present his scheduled aerobatic displays. (Photograph by Joe Binder.)

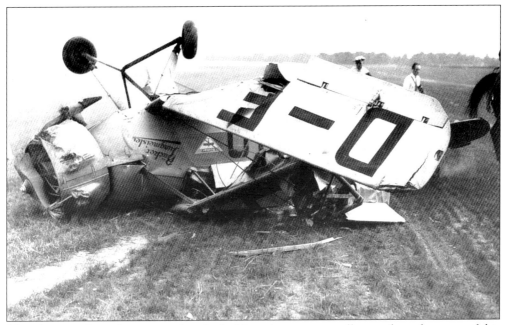

This photograph emphasizes just how lucky Hagenburg was to walk away from the scene of this crash with only minor injuries. (Photograph by Joe Binder.)

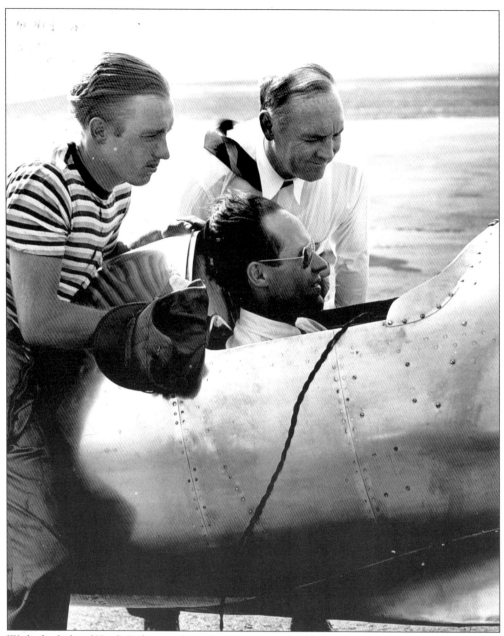

With the help of Keith Rider, on the right, and an unidentified member of his ground crew, left, Harry Crosby runs up the engine on his CR-4 racer in preparation for the 1939 National Air Races in Cleveland. (*Cleveland Press* Collection, CSU.)

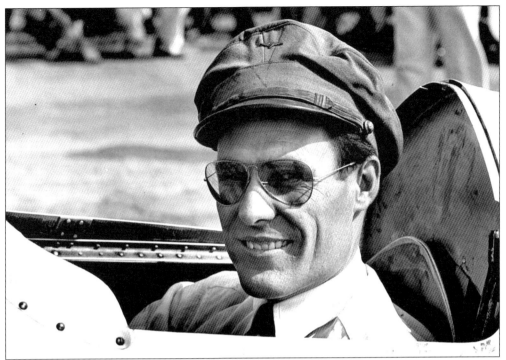

In this photograph from 1936, Harry Crosby smiles from the cockpit of his CR-3 racer. Various problems restricted the aircraft's top speed and led to a disappointing sixth place finish in that year's Thompson Trophy Race. Shortly afterward, the racer was destroyed in a crash that severely injured Crosby. He recovered in time to return the following year with a much-improved racer of his own design, the CR-4. (Photograph by Fred Bottomer, *Cleveland Press* Collection, CSU.)

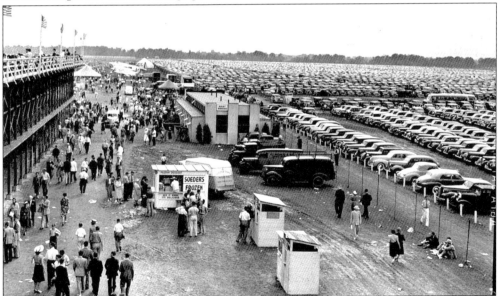

With bleachers filled with spectators on the left, this view provides a glimpse behind the scenes at the 1938 Nationals in Cleveland. Note the lineup of military aircraft in the distance and the vast number of parked cars on the right. (*Cleveland Press* Collection, CSU.)

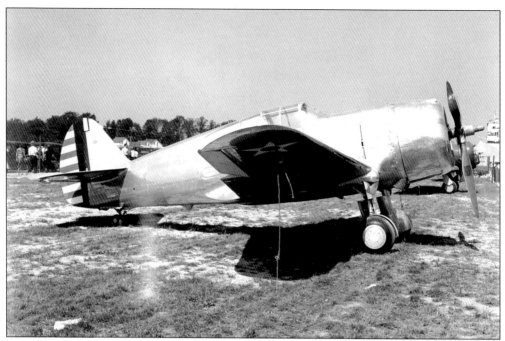

This Curtiss P-36 was photographed at Cleveland during the 1938 National Air Races. Re-engined with a liquid cooled Allison V-12, this aircraft became the P-40 and saw wide use in World War II. (Author's Collection.)

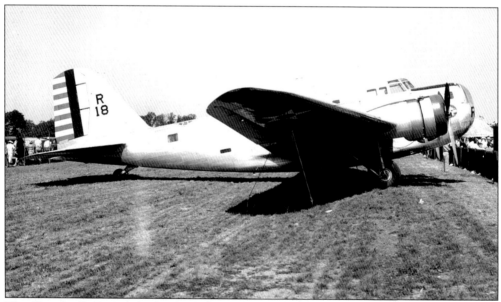

This Douglas B-18 visited Cleveland during the 1938 National Air Races. Originally chosen by the army instead of the B-17, this aircraft was not a success and is barely remembered today. (Author's Collection.)

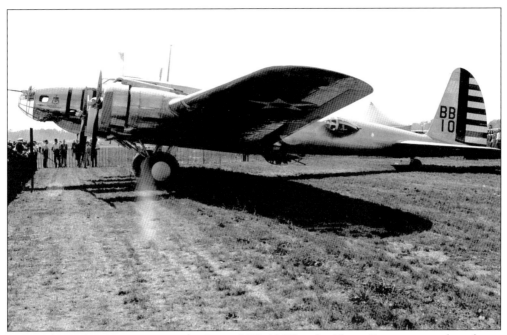

Destined to achieve greatness in the Second World War, the Flying Fortress was a brand-new piece of equipment when this Y1B-17 assigned to the 2nd Bomb Group at Langley Field, Virginia, visited the 1938 National Air Races. (Author's Collection.)

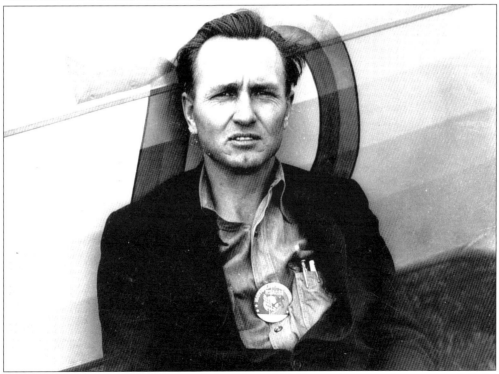

Bill Schoenfeldt owned and sponsored the Schoenfeldt Firecracker racer flown successfully by Tony LeVier at Cleveland in 1938 and 1939. (Photograph by Joe Binder.)

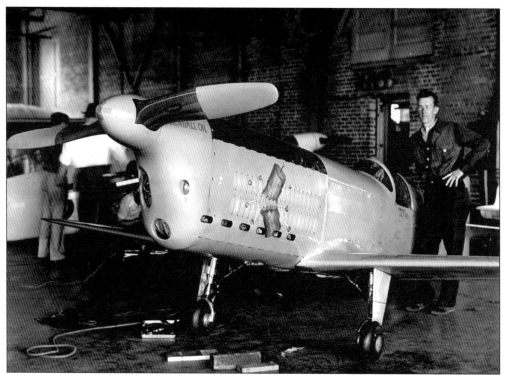

Tony LeVier poses with his Schoenfeldt Firecracker racer during preparations for the 1938 National Air Races. LeVier won the Greve Trophy Race that year by a margin of four seconds. Immediately afterward, engine trouble led to a hasty forced landing. The Firecracker was too badly damaged to participate in the Thompson Trophy Race, but LeVier vowed to return the following year. (*Cleveland Press* Collection, CSU.)

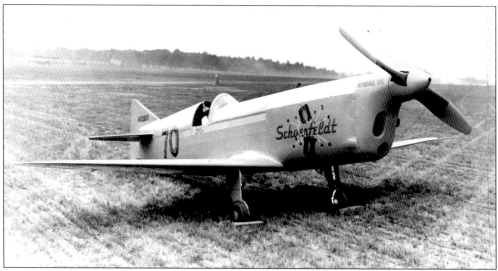

The Schoenfeldt Firecracker as it appeared in 1938 is shown here. Flown by Tony LeVier, it won the Greve Trophy Race, defeating its closest rival, Art Chester, by a mere four seconds. Judging by his hand gesture, the Firecracker's pilot must not have been pleased to have his picture taken. (Photograph by John Nash, *Cleveland Press* Collection, CSU.)

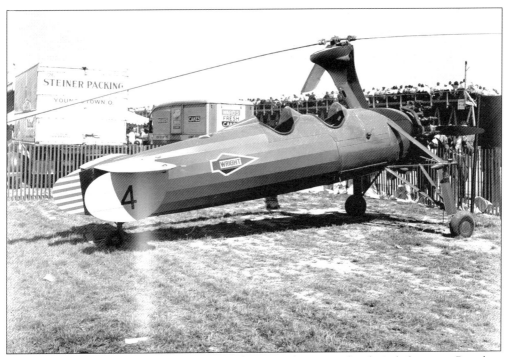

Now nearly forgotten, the autogiro was a direct predecessor of today's helicopter. Based at Wright Field in Dayton, Ohio, this Army Air Corps–flown aircraft is pictured in Cleveland while visiting the National Air Races in 1938. (Author's Collection.)

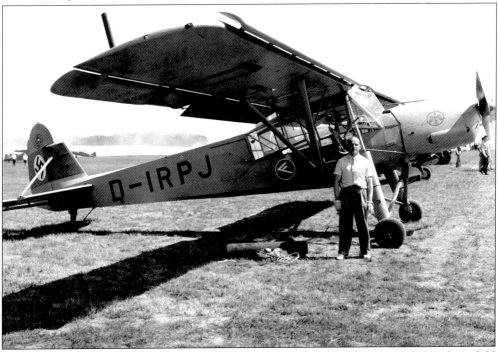

Pilot Emil Kropf came all the way from Germany to demonstrate the remarkable short field landing and takeoff capability of this Fiesler Storch in 1938. (Author's Collection.)

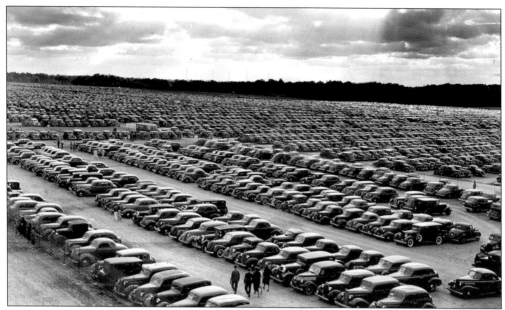

This vast expanse of parked cars helps to emphasize the size of the crowds the air races drew. Traffic must have been a real problem each day when the races ended. The photograph was taken in September 1937. (*Cleveland Press* Collection, CSU.)

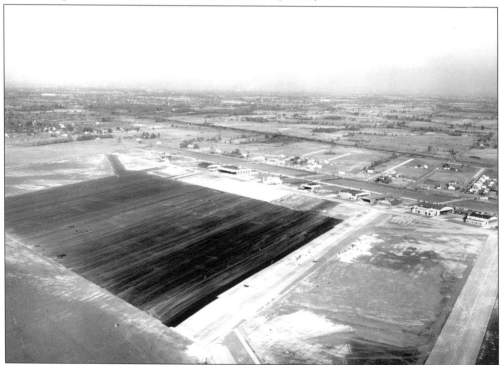

Improvements at the Cleveland airport were made steadily during the 1930s. When this picture was taken in the fall of 1939, the ramp in front of the hangars on the airport's east side was said to be the largest paved surface in the world. (Photograph by Clyde H. Butler, *Cleveland Press* Collection, CSU.)

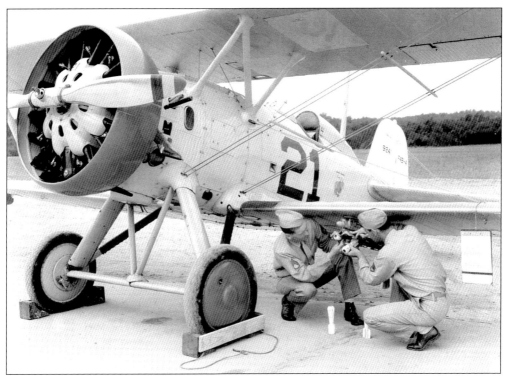

When photographed in 1935, this U.S. Marine Corps Boeing F4B-4 was considered state-of-the-art. Its speed ring engine cowling and metal-covered fuselage were inspired by air racing. Despite these features, rapid advances in aircraft design meant that the days of the wire-braced open cockpit biplane were numbered. (*Cleveland Press* Collection, CSU.)

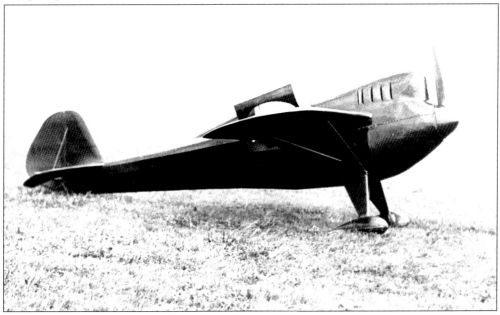

This photograph shows the Folkerts SK-1 as it appeared at the 1935 National Air Races in Cleveland. (Photograph by Joe Binder.)

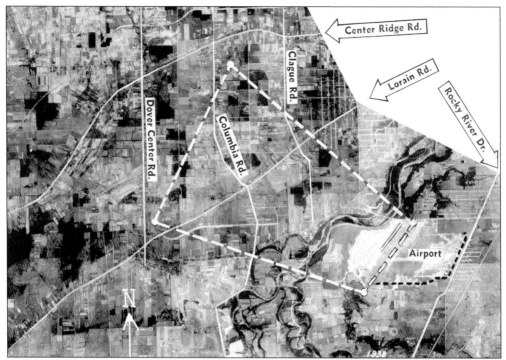

Taken in August 1938, this aerial photograph shows the 10-mile course used for that year's Thompson and Greve Trophy Races. (*Cleveland Press* Collection, CSU.)

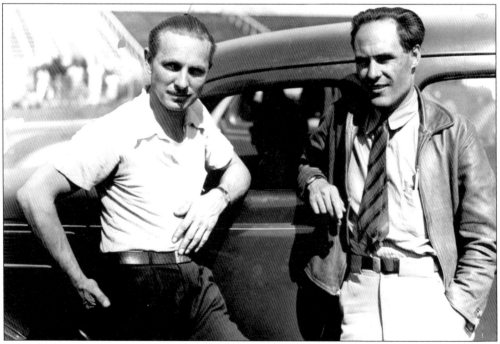

Art Chester, seen here on the left, stops to talk with Harry Crosby during the 1939 Nationals at Cleveland. Strong but ill-fated competitors, both were destined to die in aircraft accidents. (*Cleveland Press* Collection, CSU.)

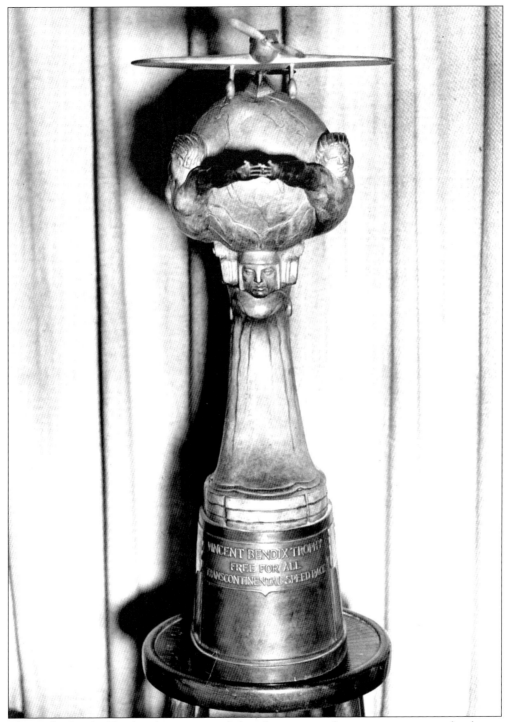

This is the Bendix Trophy, the prize awarded to the victor in the cross-country race that began the National Air Races each year starting in 1931. (*Cleveland Press* Collection, CSU.)

An extraordinary ramp full of airplanes appears at the National Air Races in 1934. In the foreground is the Keith Rider R-1, owned and flown that year by Rudy Kling. Next is Benny Howard's *Ike*, followed by Earl Ortman's Keith Rider R-2. The next aircraft is Steve Wittman's *Chief Oshkosh*. The final aircraft is Art Chester's *Jeep*. The two Keith Riders were destroyed in crashes in the 1930s. The others still exist. (Joe Binder Collection.)

This Ryan ST was flown by noted aerobatic pilot Tex Rankin. His aerobatic displays entertained crowds in Cleveland in 1937 and 1938. The Ryan ST was a widely admired airplane back in the 1930s, and this particular aircraft still exists today. (Photograph by Joe Binder.)

Gladys O'Donnell accepts congratulations and a trophy after winning the Amelia Earhart Trophy Race at the 1937 Nationals in Cleveland. She also received a cash prize of $4,500. (Photograph by Joe Binder.)

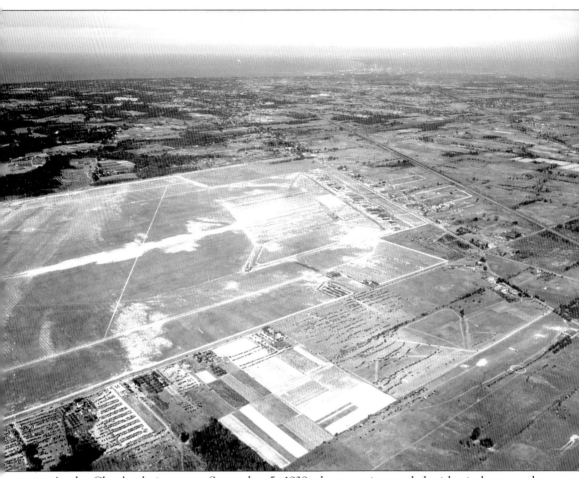

At the Cleveland airport on September 5, 1938, the ramp is crowded with airplanes, and a white diagonal line bisecting the airport is clearly visible. Normal operations continued on the right, while the area to the left was reserved for activities related to the air races. To the lower right may be seen the single hangar of a separate airport with a biplane back taxiing on its grass runway. (*Cleveland Press* Collection, CSU.)

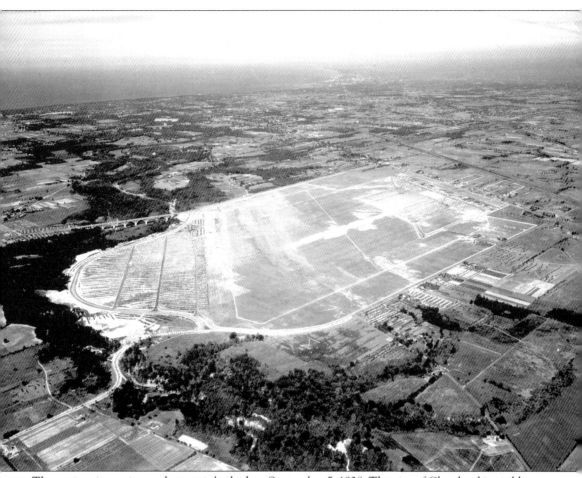

The entire airport is seen here as it looked on September 5, 1938. The city of Cleveland is visible in the middle distance. (*Cleveland Press* Collection, CSU.)

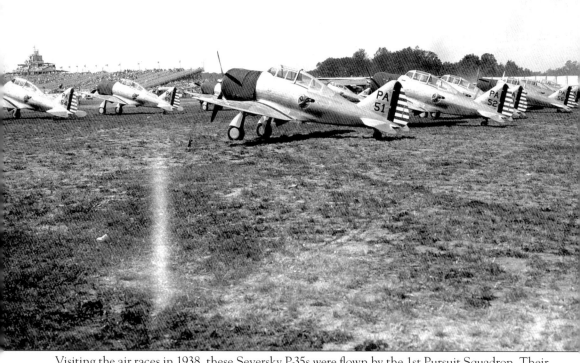

Visiting the air races in 1938, these Seversky P-35s were flown by the 1st Pursuit Squadron. Their design reflected much modern technology derived from successful air racers. Modified fighters of this basic design started the trend of fighter aircraft competing in the air races. The P-35 was a direct ancestor of the Republic P-47, one of the outstanding combat aircraft of the Second World War. (Author's Collection.)

These Grumman F3F-2 fighters were displayed at the National Air Races in 1938. This was the final biplane fighter flown by the Navy and Marine Corps. Well liked by their pilots, these airplanes were already obsolete. One example of this aircraft survives today and may be seen at the Museum of Naval Aviation in Pensacola, Florida. (Author's Collection.)

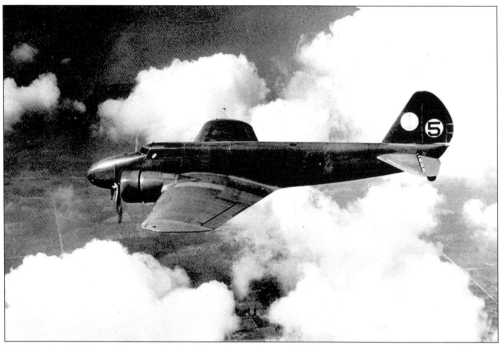

Only in the 1930s would a standard airliner be easily modified to participate in an air race. Roscoe Turner flew this Boeing 247 in the 1934 MacRobertson Race from London to Melbourne. After the race, it was returned to United Airlines. It may be seen today at the National Air and Space Museum. (*Cleveland Press* Collection, CSU.)

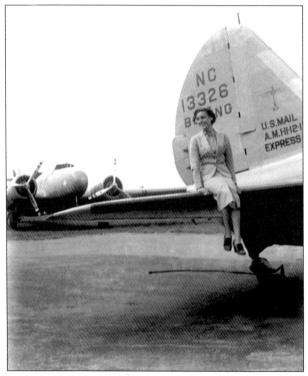

In its airline guise, the Boeing 247 was a frequent visitor to Cleveland in the late 1930s. United Airlines stewardess Betty Anzuena Butler poses for a photograph on the ramp at Cleveland in 1937. (Photograph courtesy of Molly Tewksbury.)

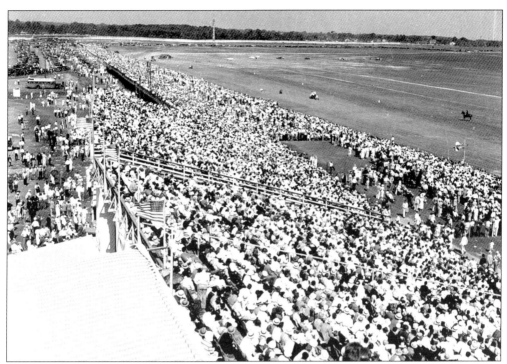

Taken on Labor Day 1935, this photograph shows the large crowds the air races drew even as the country struggled to recover from the Depression. (*Cleveland Press* Collection, CSU.)

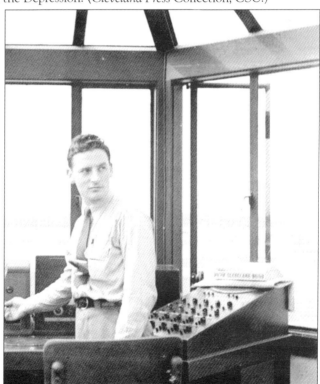

This photograph of United Airlines passenger agent Robert Butler gives a glimpse of the interior of the control tower at the Cleveland airport as it appeared in the late 1930s. (Photograph courtesy of Molly Tewksbury.)

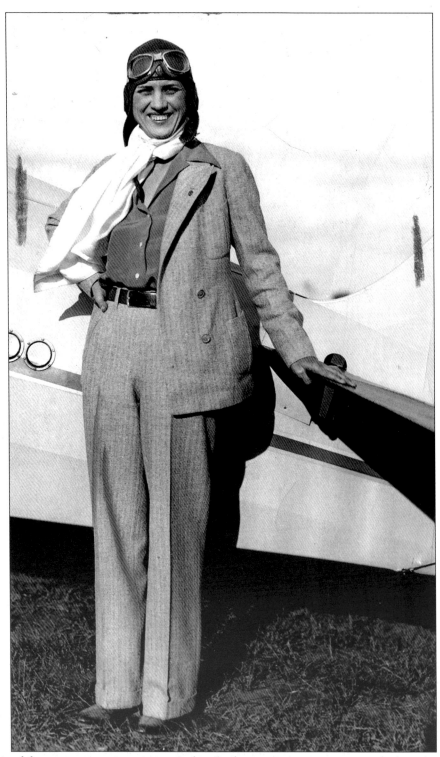

Destined for great success in aviation, Jackie Cochran was just getting started when she posed with her Cabin Waco at Roosevelt Field in October 1933. (*Cleveland Press* Collection, CSU.)

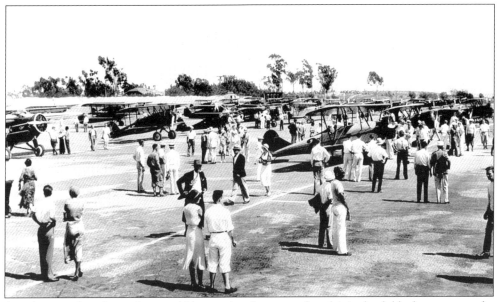

A gathering of airplanes that would be worth a fortune today, this is the field of contestants for the 1931 National Air Derby from Clover Field in Santa Monica, California, to the Cleveland airport. Taken as the race was about to begin, the scene includes Wacos, Travel Airs, Rearwins, Monocoupes, a Fokker, and a variety of other types. (*Cleveland Press* Collection, CSU.)

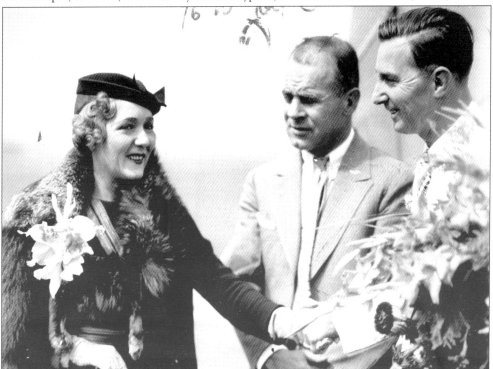

The National Air Races frequently drew celebrities from Hollywood. Here actress Mary Pickford greets Jimmy Doolittle and Cliff Henderson on September 1, 1934. (*Cleveland Press* Collection, CSU.)

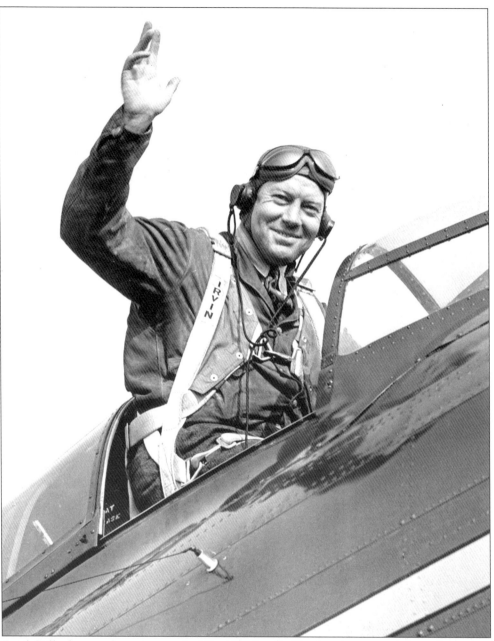

Frank Fuller has good reason to smile. The 1939 Bendix Trophy winner waves from the cockpit of his Seversky racer before stepping down to claim $12,500 in prize money. (*Cleveland Press Collection, CSU.*)

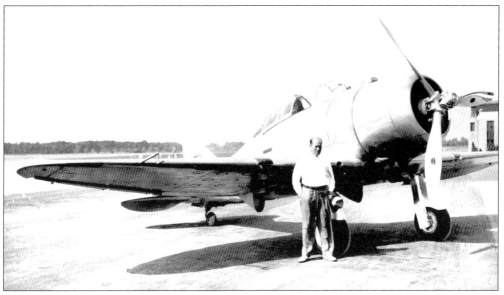

Frank Fuller poses with his 1937 Bendix Trophy contender, a demilitarized Seversky P-35. (*Cleveland Press* Collection, CSU.)

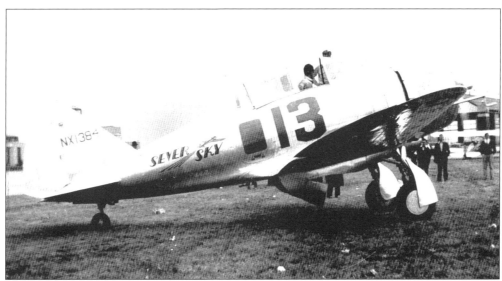

By 1938, the Bendix Trophy Race had become a contest to determine who flew the fastest Seversky racer, Frank Fuller or Jackie Cochran. Cochran won that year with the aircraft pictured here as mechanics check its engine's performance just before the race. (*Cleveland Press* Collection, CSU.)

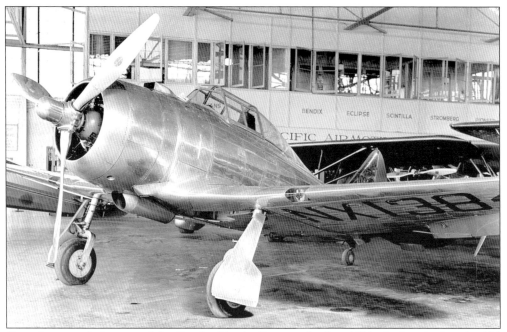

Seversky aircraft dominated the Bendix Trophy Race in the late 1930s. Jackie Cochran's 1939 race entry is seen here in the Pacific Airmotive hangar at Mines Field, Los Angeles, California, shortly before the race. (*Cleveland Press* Collection, CSU.)

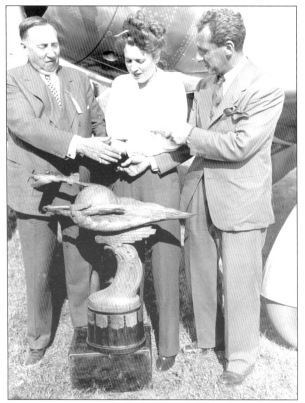

The 1938 Bendix Trophy winner, Jackie Cochran, is congratulated by Vincent Bendix (left), the trophy's donor, and Alexander de Seversky, the designer of her winning aircraft. (*Cleveland Press* Collection, CSU.)

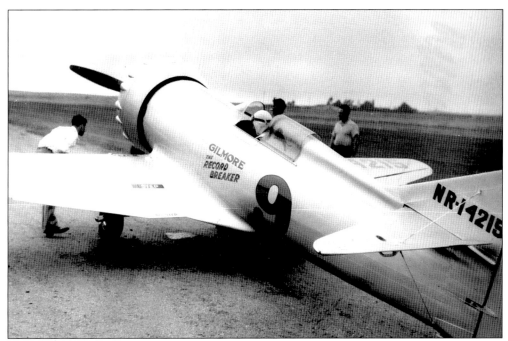

This is the Keith Rider R-3 as flown by Earl Ortman in the 1935 Bendix Trophy Race. A navigation error spoiled Ortman's chance of winning. He withdrew from the race after discovering damage to the aircraft's engine cowling during a fuel stop at Kansas City. (*Cleveland Press Collection, CSU.*)

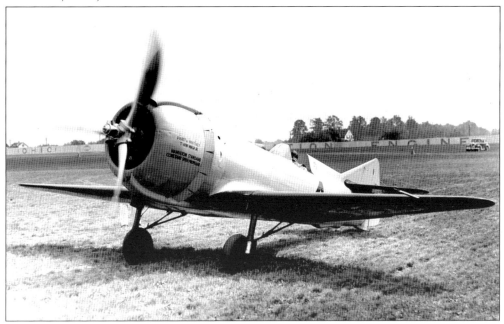

Earl Ortman runs up the engine of his yellow and black Marcoux-Bromberg racer at Cleveland in 1939. Originally the Keith Rider R-3, the airplane was revised several times and may be seen today in the New England Air Museum in Windsor Locks, Connecticut. (*Cleveland Press Collection, CSU.*)

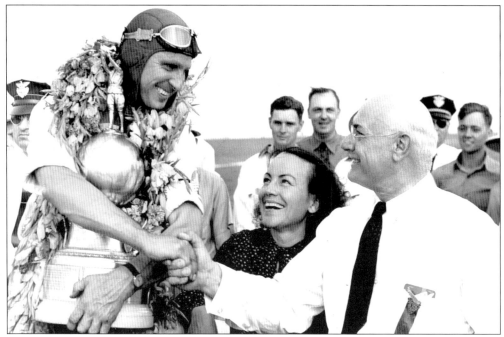

Louis W. Greve, head of the Cleveland Pneumatic Tool Company, congratulates Art Chester and his wife after Chester's record-setting victory in the 1939 Greve Trophy Race. (*Cleveland Press* Collection, CSU.)

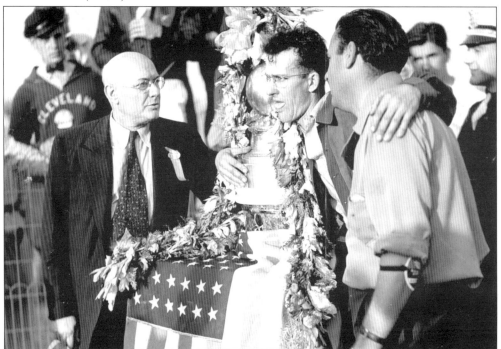

Louis W. Greve, on the left, presents the Greve Trophy to Tony LeVier. LeVier's arm is around Bill Schoenfeldt, the owner of his winning racer, the Schoenfeldt Firecracker. (*Cleveland Press* Collection, CSU.)

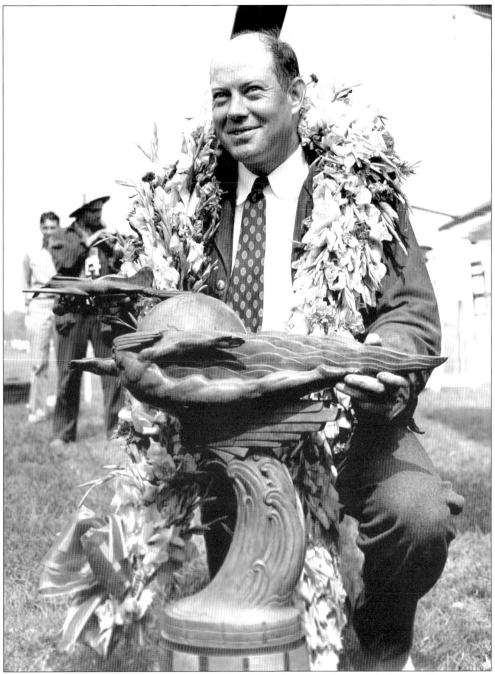

Successful long-distance racer Frank Fuller poses with his prize, the Bendix Trophy. He won the race twice, flying his trademark Seversky racer. (*Cleveland Press* Collection, CSU.)

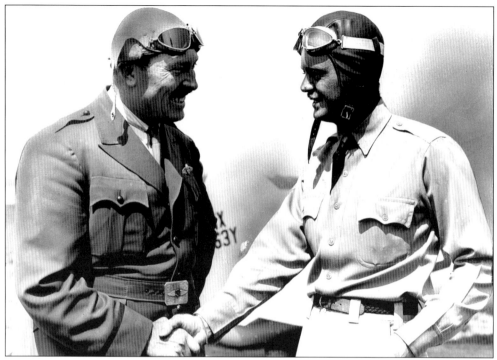

Roscoe Turner greets Joe Mackey, seen here on the right. When Turner moved up to his newly constructed Laird Turner Racer, he permitted Mackey to fly his old Wedell-Williams racer with the understanding that he would receive half of Mackey's winnings. (*Cleveland Press* Collection, CSU.)

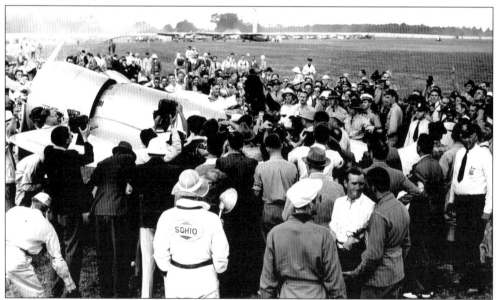

Moments after winning the 1938 Thompson Trophy Race, Roscoe Turner emerges from the cockpit of his Laird-Turner Racer amid a crowd of well-wishers in the winner's circle. In the right foreground, the smiling man in the white shirt is Earl Ortman. He finished second and was among the first to congratulate Turner. (*Cleveland Press* Collection, CSU.)

Four

THE 1940S

In 1946, after a lapse of seven years, the National Air Races returned to the Cleveland Municipal Airport.

Both the venue and the competitors were different. The prewar buildings constructed along the airport's western edge were gone, displaced by wartime expansion. Spectators now watched the races from a new venue constructed on the south side of the airport.

Master promoter Cliff Henderson was also gone, having announced his retirement in 1939. While some of the prewar pilots returned and did well, a new generation of young military-trained pilots was eager to replace them.

The days of privately designed and funded airplanes dominating the Thompson Trophy Race were over. The postwar winners would fly modified World War II fighters.

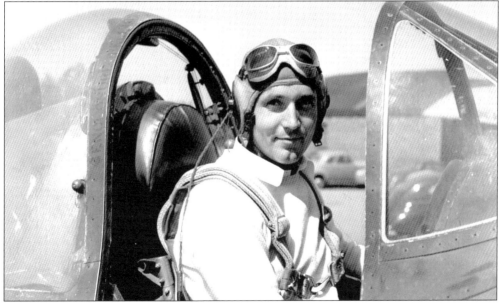

Cook Cleland was destined to dominate postwar competition for the Thompson Trophy. He is seen here in the cockpit of a Corsair in 1946. (*Cleveland Press* Collection, CSU.)

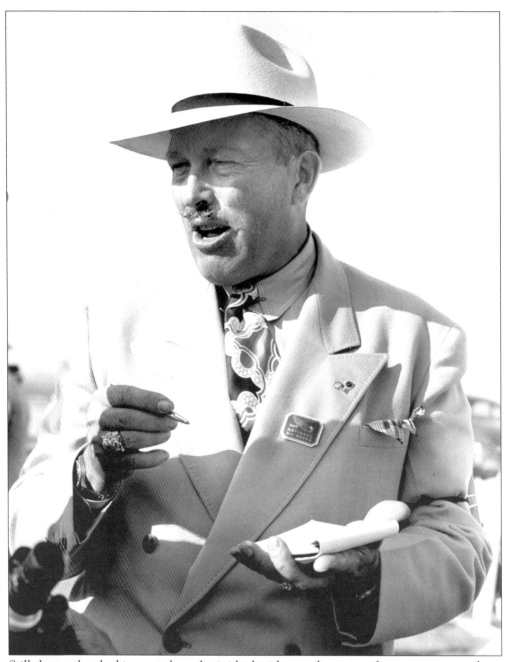

Still dapper, but looking somehow diminished without a lion, a uniform, or a racing plane, Roscoe Turner is seen here in 1947 attending the National Air Races as an observer. (*Cleveland Press* Collection, CSU.)

A confident Art Chester smiles from the cockpit of *Sweet Pea*, September 3, 1947. (*Cleveland Press* Collection, CSU.)

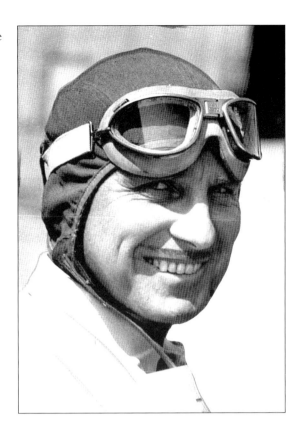

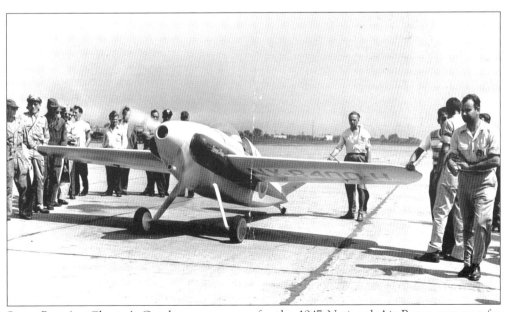

Sweet Pea, Art Chester's Goodyear race entry for the 1947 National Air Races, prepares for flight. (*Cleveland Press* Collection, CSU.)

Paul A. DeBlois, a 25-year-old pilot from Longmeadow, Massachusetts, prepared the home-built racer he poses with in the foreground to participate in the Goodyear race at the 1948 National Air Races. (*Cleveland Press* Collection, CSU.)

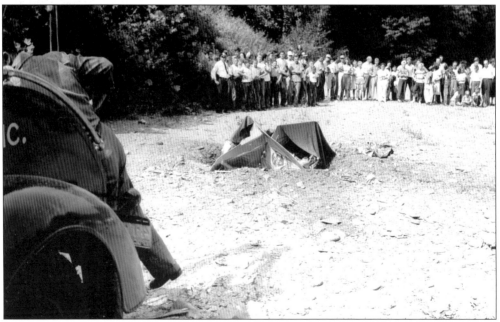

DeBlois met a tragic end. On September 3, 1948, his airplane suffered a catastrophic in-flight structural failure. He was killed in the resulting crash. As police restrained curious onlookers in the distance, the tow truck driver in the foreground begins the grisly task of recovering the pilot's body from the wreckage. (Author's Collection; photograph by George K. Scott.)

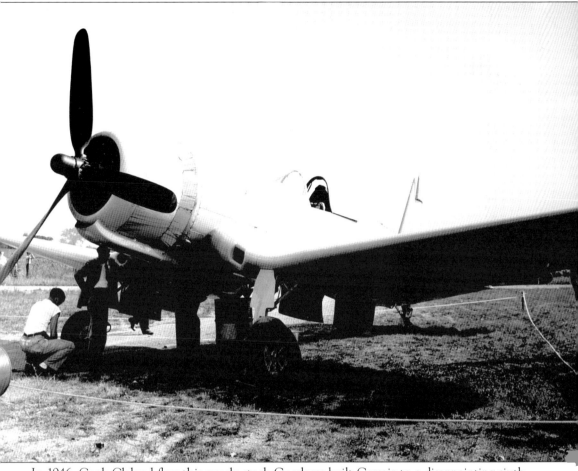

In 1946, Cook Cleland flew this nearly stock Goodyear-built Corsair to a disappointing sixth place finish in the Thompson Trophy Race. Undeterred, he returned the following year with a team of vastly more powerful Super Corsairs and proceeded to leave nearly everyone in his wake. Before the competition ended in 1949, Cleland won the Thompson Trophy twice and really give the spectators their money's worth in the process. (*Cleveland Press* Collection, CSU.)

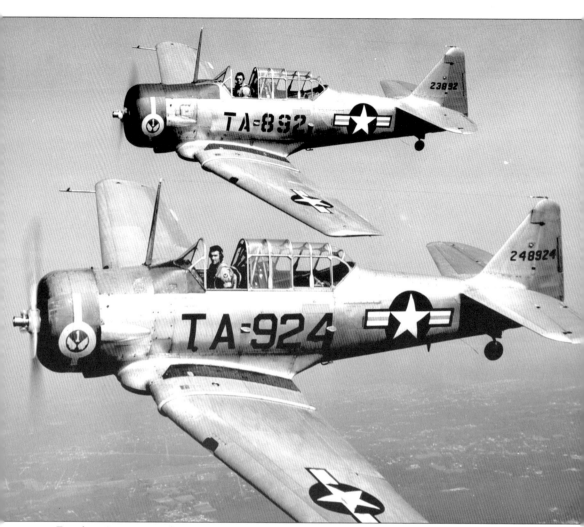

For the 1948 National Air Races, these Air Force Reserve AT-6's traveled from New York to Cleveland to put on an aerobatic display. The aircraft in the foreground was flown by Lt. William J. Fenton. Flying on his wing is Lt. Robert S. Fitzgerald. (*Cleveland Press* Collection, CSU.)

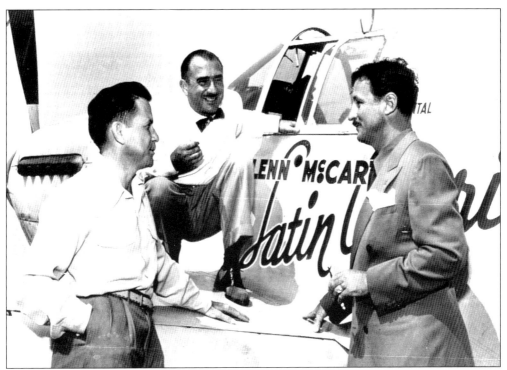

During preparations for the 1948 Bendix Trophy Race, Linton Carney (left), and Paul Mantz (center), talk with sponsor Glenn McCarthy (right). McCarthy was a wealthy Houston hotel owner. The P-51 was painted light gray overall with green lettering. Mantz flew the airplane to first place. (*Cleveland Press* Collection, CSU.)

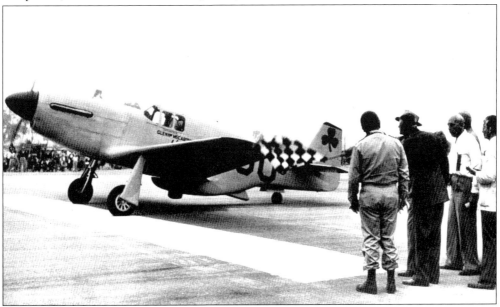

The starter's flag drops, signaling Linton Carney to begin his takeoff, starting the 1948 Bendix Trophy Race. The start was delayed two hours by fog. Carney took second place with an average speed of 446.1 miles per hour. (*Cleveland Press* Collection, CSU.)

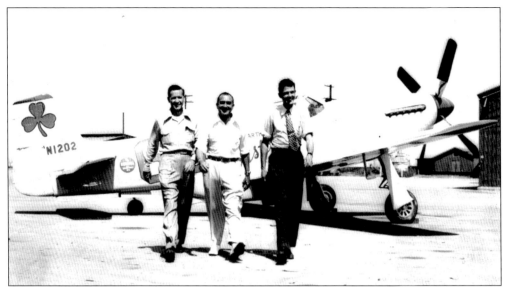

For 1948, Paul Mantz put together an excellent team, determined to win first, second, and third place in that year's Bendix Trophy Race. He nearly did it. Linton Carney, seen here on the left, flew the aircraft in the background to second place. Mantz took first, but Edmund Lunken, right, was beaten to third place by Jackie Cochran, flying a P-51C with her usual race number 13. (*Cleveland Press* Collection, CSU.)

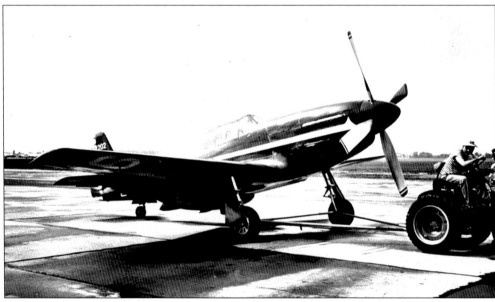

Paul Mantz achieved disappointing results in the prewar Bendix Trophy races. He returned after World War II to dominate the event. This P-51C is his 1947 race winner, seen here being towed to a parking spot after the race was won. Later flown by Charles F. Blair, the airplane was used for a remarkable solo flight across the North Pole in May 1951. Painted in Blair's markings, it survives today in the collection of the National Air and Space Museum. (*Cleveland Press* Collection, CSU.)

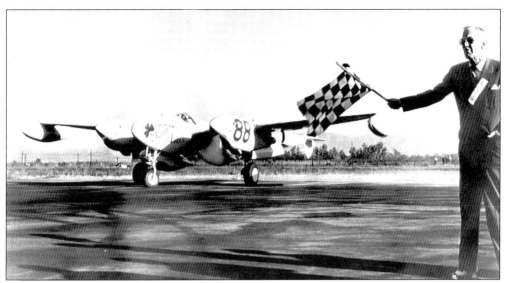

In the 1947 Bendix Trophy Race, Glenn McCarthy sponsored the P-38 shown here. The wingtip tanks installed for the race were not standard and were an immediate source of trouble. Moments after this picture was taken, the right tank dropped to the runway and exploded. Pilot Jim Ruble decided to continue with the race. (*Cleveland Press* Collection, CSU.)

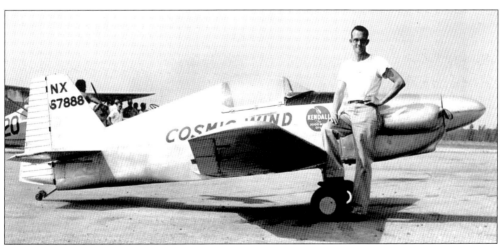

Tony LeVier was one of several prominent prewar racers who returned to Cleveland when racing resumed in 1946. He is seen here a year later with his entry for the Goodyear Trophy Race. (*Cleveland Press* Collection, CSU.)

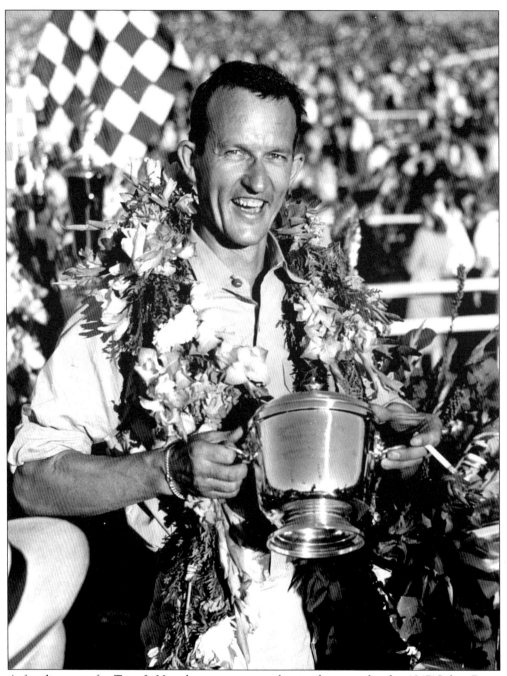

A familiar pose for Tony LeVier; he accepts a trophy, in this case for the 1947 Sohio Race. (*Cleveland Press* Collection, CSU.)

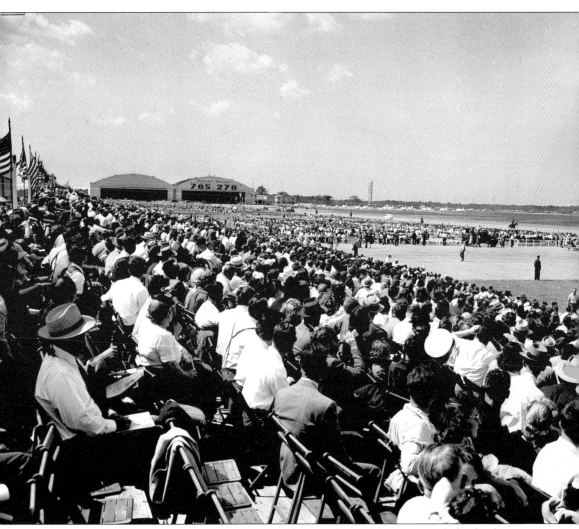

This view gives a sense of what the view from the stands was like in 1946. (*Cleveland Press Collection, CSU.*)

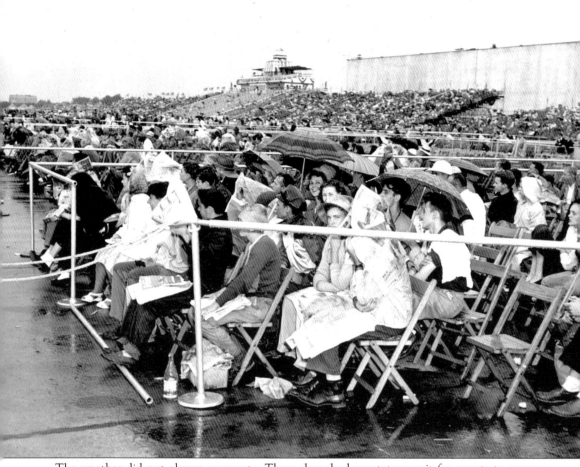

The weather did not always cooperate. These drenched spectators wait for events to resume, Labor Day 1948. (*Cleveland Press* Collection, CSU.)

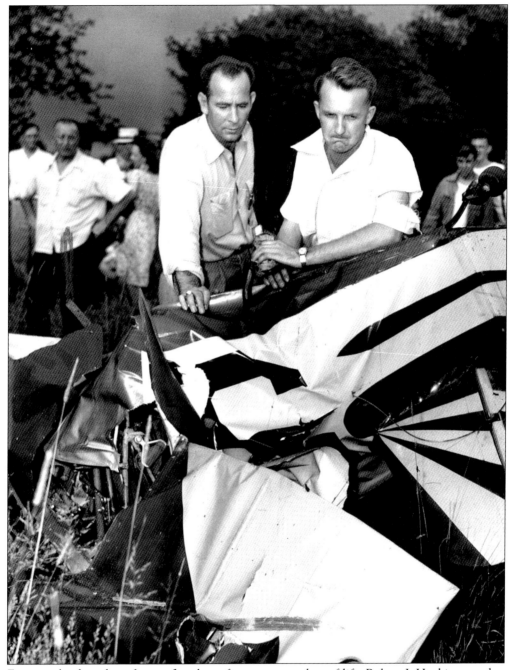

Fortunately, these long faces reflect loss of property, not loss of life. Robert J. Hopkins, on the left, looks over his wrecked aircraft with his pilot, Claude P. Smith. Smith was forced to bail out when he experienced an in-flight structural failure. (Photograph by Byron Filkins, *Cleveland Press* Collection, CSU.)

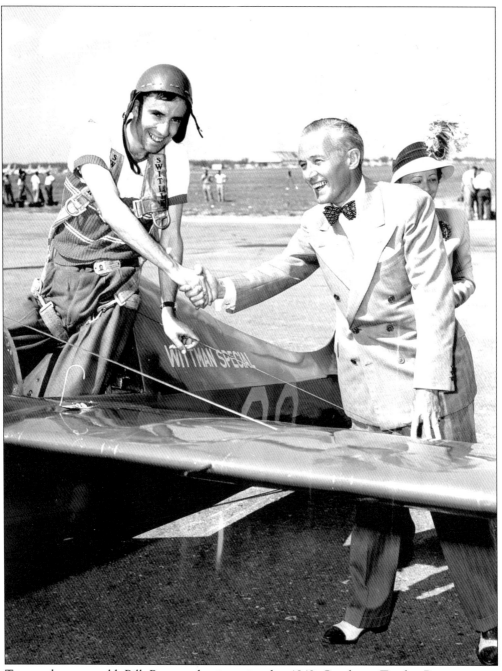

Twenty-three-year-old Bill Brennand, victor in the 1949 Goodyear Trophy Race, accepts the congratulations of J. M. Linforth, a Goodyear Company vice president. (*Cleveland Press Collection*, CSU.)

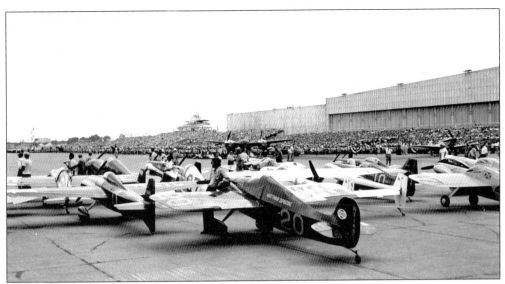

With a P-38 and a Griffon-engined Spitfire visible in the background, 1949 Goodyear Race contenders are parked in the foreground. Race No. 20 was flown to victory by Bill Brennand at a speed of 177.34 miles per hour, a new record. Race fans with long memories knew it in the 1930s as Steve Wittman's *Chief Oshkosh*. The airplane survives today in the collection of the National Air and Space Museum. (*Cleveland Press* Collection, CSU.)

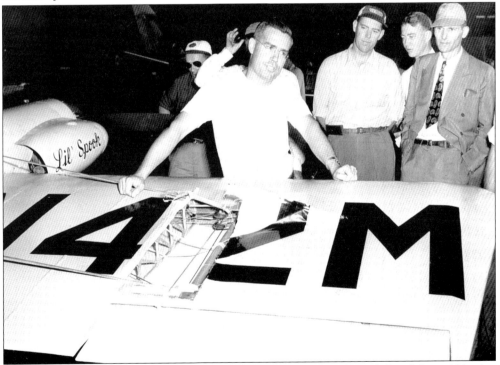

Steve Beville of Hammond, Indiana, reacts to damage to his aircraft, *Little Spook*. Incredibly, this damage was done purposely by a drunken pilot on the ground who was too intoxicated to realize that Beville's airplane was not the rival he intended to sabotage. Beville and *Little Spook* flew again. The vandal was identified and prosecuted. (*Cleveland Press* Collection, CSU.)

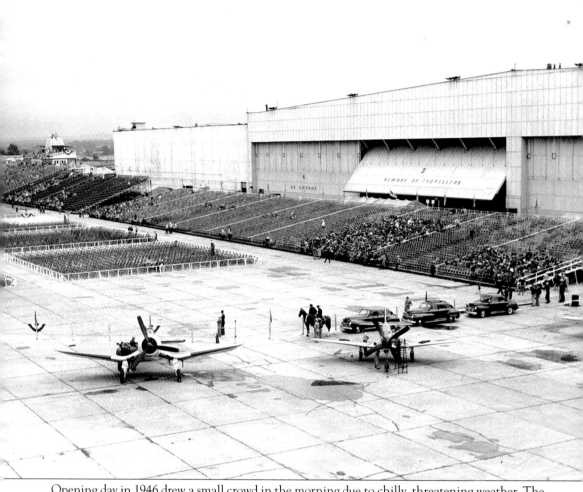

Opening day in 1946 drew a small crowd in the morning due to chilly, threatening weather. The Cleveland Mounted Police officers do not seem very interested in the Corsair and P-39 parked just a few feet away. (*Cleveland Press* Collection, CSU.)

Thompson Products president Frederick E. Crawford congratulates Thompson Trophy winner Anson Johnson in 1948. (*Cleveland Press* Collection, CSU.)

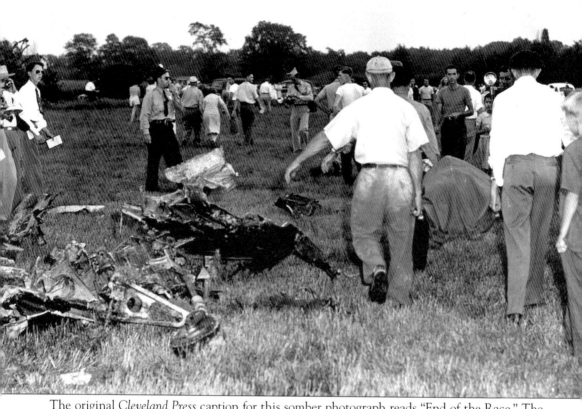

The original *Cleveland Press* caption for this somber photograph reads "End of the Race." The body of Corsair pilot and Thompson Trophy contender Tony Janazzo is borne gently away from the scene of the crash that took his life in Strongsville, Ohio, September 1, 1947. (*Cleveland Press* Collection, CSU.)

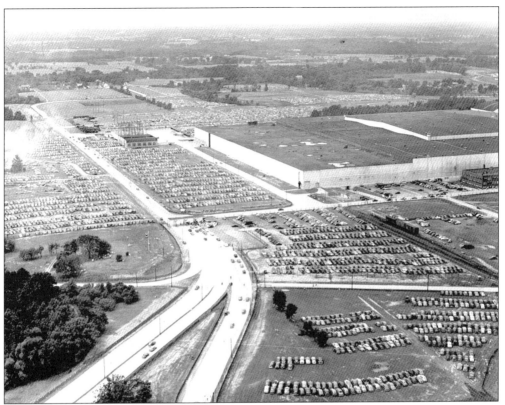

The main entrance to the Cleveland National Air Races is seen from the air in September 1947. (*Cleveland Press* Collection, CSU.)

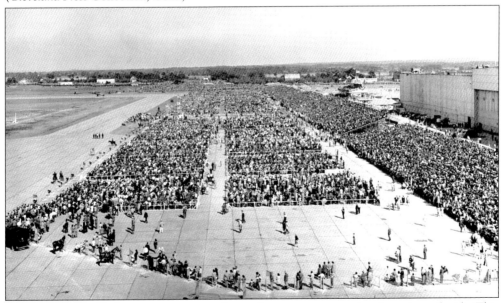

After World War II, the spectators were relocated to a new area on the airport's south side. This photograph was taken on Labor Day 1946 and provides a good overview of the new facilities. (*Cleveland Press* Collection, CSU.)

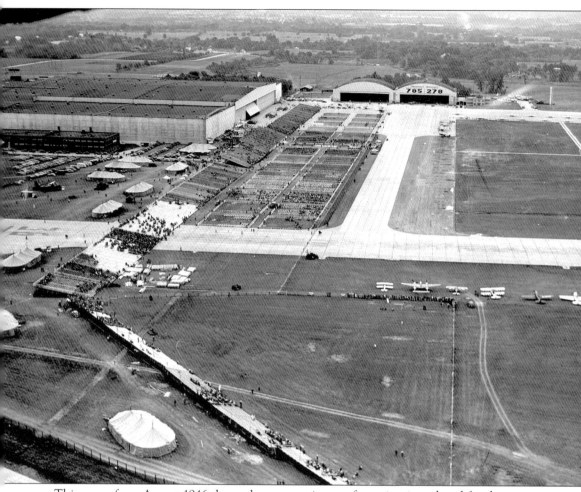

This scene from August 1946 shows the new seating configuration introduced for the postwar National Air Races. The new facilities were located on the airport's southern edge and were made necessary because wartime expansion claimed the former site along the airport's western edge. Aircraft visible include P-38s, P-80s, AT-6s, P-39s, a Stearman, a Monocoupe, and a Bücker Jungmeister. (*Cleveland Press* Collection, CSU.)

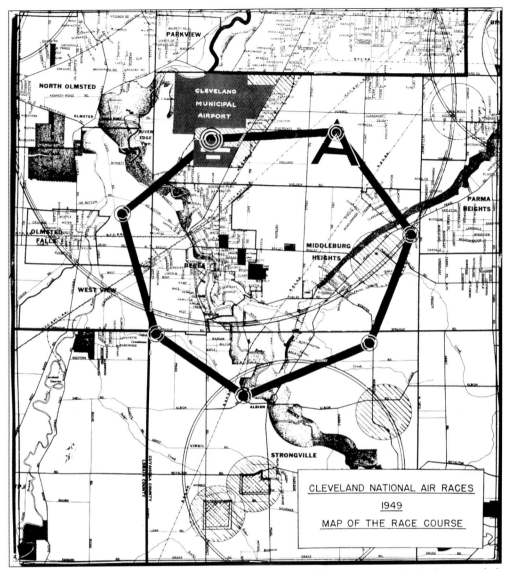

Due to the higher speeds of postwar racing planes, the size of the race course had to be expanded. This map shows the course used in the final presentation of the National Air Races. (*Cleveland Press* Collection, CSU.)

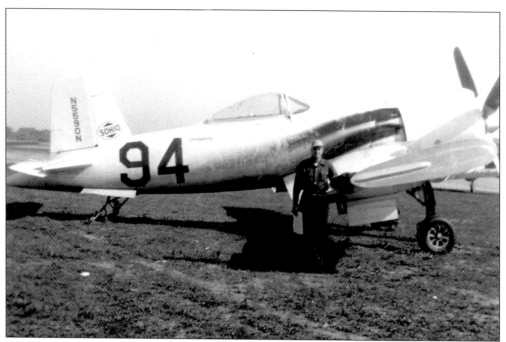

This view shows Cook Cleland's Super Corsair, the final winner of the Thompson Trophy, as it appeared shortly after the race was won. (Author's Collection; photograph by George K. Scott.)

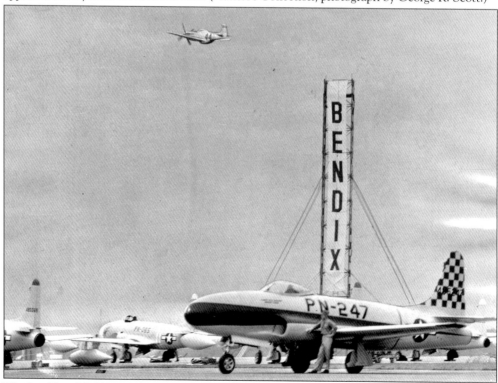

The Lockheed P-80s seen here at the 1946 National Air Races relegate the lone P-51 in the air to the background, a portent of things to come. (*Cleveland Press* Collection, CSU.)

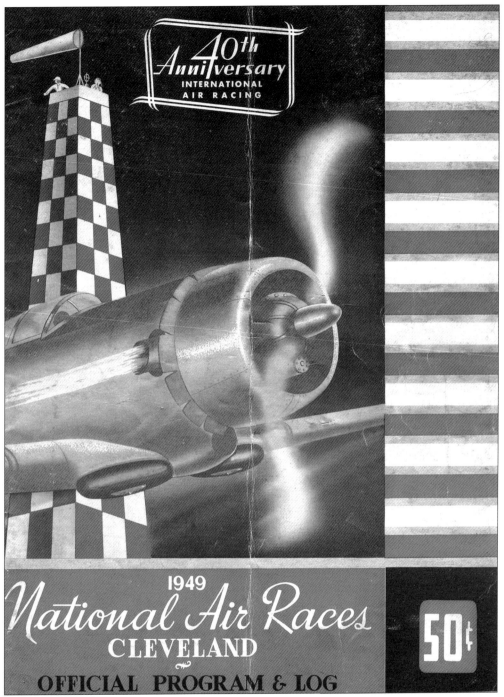

This is the cover of the final program for the National Air Races, issued in 1949. (Courtesy of Joe Stamm.)

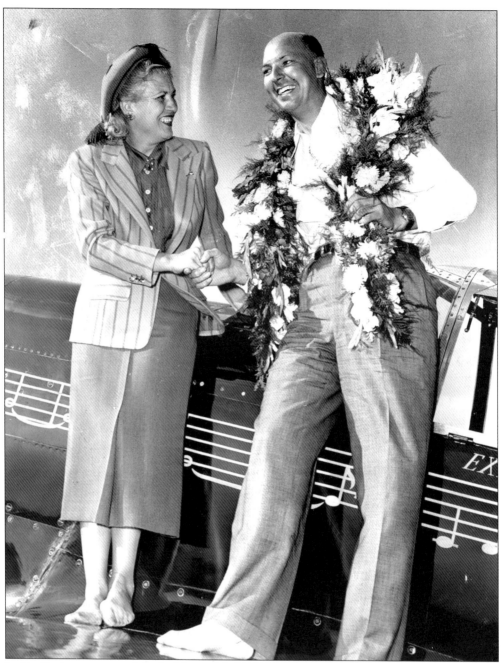

Jackie Cochran, owner of the highly-modified P-51C racer named "Beguine," congratulates pilot Bill Odom after his victory in the 1949 Sohio Race. Note the fact that they are not wearing shoes. This is probably to avoid marring the highly polished racer's finish. (*Cleveland Press* Collection, CSU.)

SPONSORED BY AIR FOUNDATION

Today's Racing Entries
Saturday, September 3, 1949

BENDIX TROPHY RACE
TRANSCONTINENTAL SPEED DASH

"R" Division

No.	Pilot	Airplane	Color
24	L.'H. Cameron	Martin B-26-C	Silver
90	Joe DeBona	North American F-51-C	Light Blue
46	E. P. Lunken	North American F-51	Gray
60	S. H. Reaver	North American F-51	Gray
81	D. E. Bussart	DeHavilland Mosquito	Blue
61	Vincent Perron	Republic AT-12

"J Division

Pilot	Organization	Airplane
Lt. Col. Leo C. Moon		F-84 Thunderjet
Air Materiel Command, Wright-Patterson AFB.		
Major Vernon A. Ford		F-84 Thunderjet
Air Materiel Command, Wright-Patterson AFB.		
Capt. John C. Newman		F-84 Thunderjet
Air Materiel Command, Wright-Patterson AFB.		
Capt. Franklin M. Rizer		F-84 Thunderjet
Air Materiel Command, Wright-Patterson AFB.		

GOODYEAR TROPHY RACE
LIGHT PLANE CLASS CHAMPIONSHIPS

1st Heat

No.	Pilot	Airplane	Color
51	Charles Barton	Special	Red
4	A. E. Custer, Jr.	Cosmic Wind	Bronze & Cream
97	W. B. Denight	Denight Special	Yellow
92	Wm. F. Falck	Falck Special	Red & Yellow
34	Clifford Mone	Estrellita	Yellow & Black
3	B. F. Robinson	Cosmic Wind	Red & White
63	Lt. Obie A. Smith	Anderson Special	Red & Cream

2nd Heat

No.	Pilot	Airplane	Color
5	Vincent Ast	Cosmic Wind	Green
77	S. C. Beville	Beville Special	Gray
35	H. D. Coonley	Coonley Special	Orange
94	Al Foss	Foss Special	Silver & Red
39	K. C. Sorenson	Deerfly	Black & White
47	J. W. Wilson	Little Rebel	Yellow

3rd Heat

No.	Pilot	Airplane	Color
29	C. B. Ambler	Special (Pusher)	White & Blue
16	Bob Downey	Mercury Air	Chartreuse
67	Luther Johnson	Long Special	Silver
14	J. W. Miller	Miller Special	Gray & Red
42	H. J. Ragland	Leghnor Special	Red
1	S. J. Wittman	Bonzo	Yellow

4th Heat

No.	Pilot	Airplane	Color
20	Wm. Brennand	Buster	Red
59	H. A. Christensen	Zipper	Yellow & Blue
31	J. J. Kistler	Kistler Special	Red & White
10	E. H. Ortman	Falcon Special	Blue & Cream
40	Carl Thompson	Thompson Special	Yellow & Red
84	Ralph Thompson	Balbon Special	Maroon

SOHIO TROPHY RACE
105 MILE CLOSED COURSE CLASSIC

Race No.	Pilot	Plane	Color
74	Dick Becker	Goodyear F-2-G	Blue & White
77	S. C. Beville	No. Amer. F-51-D	Silver
37	Ken C. Cooley	No. Amer. F-51	Bronze
21	M. W. Fairbrother	No. Amer. F-51	Gold
95	J. L. Harp, Jr.	Bell F-39	Yellow
13	Wm. P. Odom	No. Amer. F-51	Green
18	Ron Puckett	Goodyear F-2-G	Blue & Gray
53	Frank Singer	Bell F-63	Green
30	Charles Tucker	Bell F-63	Orchid
87	A. T. Whiteside	Bell F-63	Black & White

AMERICAN STEEL & WIRE COMPANY
NAVY JET CARRIER RACE
FROM THE CARRIER U. S. S. MIDWAY IN THE ATLANTIC OCEAN TO CLEVELAND

Pilot	Organization	Airplane
Lt. Cmdr. W. D. Biggers		F2H-1 Banshee
	Carrier Fighter Squadron 171	
Lt. T. S. Sedaker		F2H-1 Banshee
	Carrier Fighter Squadron 171	
Lt. R. S. Laird	548 Miles per hour	F2H-1 Banshee
	Carrier Fighter Squadron 171	
Lt. E. A. Buxton		F2H-1 Banshee
	Carrier Fighter Squadron 171	
Lt. R. S. Reagan		F2H-1 Banshee
	Carrier Fighter Squadron 171	
Home Base, Naval Air Station, Jacksonville, Florida		

★ ★ ★ ★ ★ ★ ★ ★ ★ ★ ★ ★

HOSTS TO F. A. I.

The following companies and institutions, members of Air Foundation, are acting as hosts to delegates to the 42nd Conference of the Federation Aeronautique Internationale during their stay in Cleveland—

American Steel & Wire Co.
Bendix Aviation Corporation
Cleveland Cap Screw Co.
Cleveland Elec. Illuminating Co.
Cleveland Graphite Bronze Co.
Cleveland News
Cleveland Press
Cleveland Plain Dealer
Cleveland Trust Company
Eaton Manufacturing Co.
Ernst & Ernst
Firestone Tire & Rubber Co.
B. F. Goodrich Co.
Goodyear Tire & Rubber Co.

The Higbee Co.
Industrial Rayon Corporation
The May Company
National City Bank
National Screw & Mfg. Co.
Republic Steel Corporation
The Standard Oil Co. (Ohio)
The Steel Improvement & Forge Co.
Thompson Products, Inc.
Tinnerman Products, Inc.
Union Bank of Commerce
The Weatherhead Co.
The White Motor Co.

1949 NATIONAL AIR RACES

This is a daily race schedule from 1949. (Courtesy of Joe Stamm.)

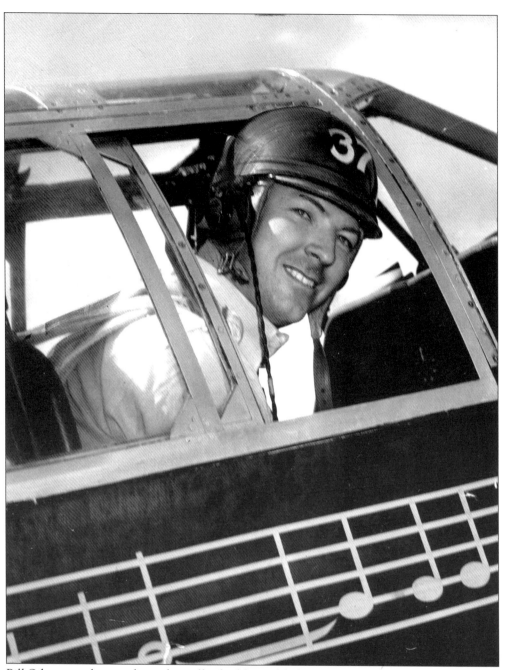

Bill Odom, seen here in the cockpit of his highly modified P-51 racer named *Beguine* had no prior experience with pylon racing. Very early in the 1949 Thompson Trophy Race, he lost control of this airplane and crashed to his death. (*Cleveland Press* Collection, CSU.)

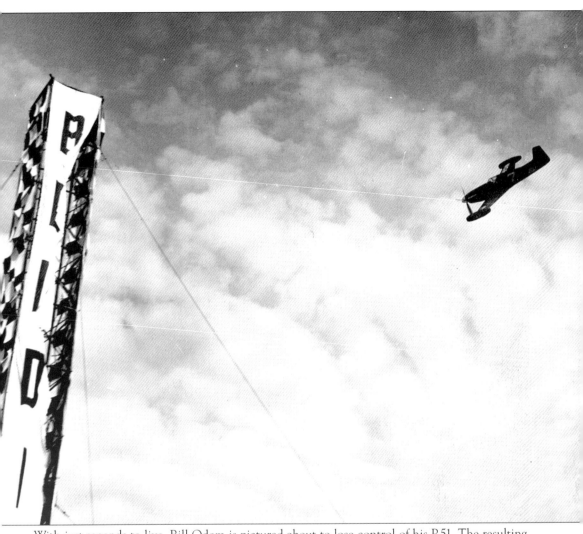

With just seconds to live, Bill Odom is pictured about to lose control of his P-51. The resulting crash killed him and a young mother and child in Berea, Ohio, and ended the Thompson Trophy Race forever. (*Cleveland Press* Collection, CSU.)

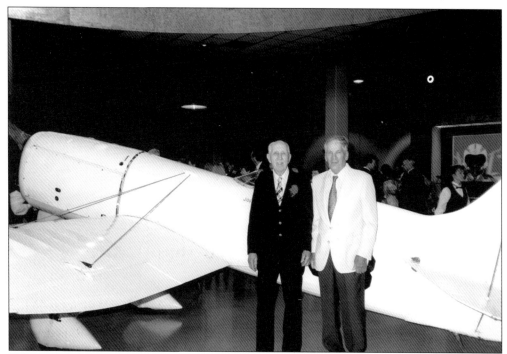

What must his thoughts have been? Five decades after he flew Howard racers to victory in the Thompson and Greve Trophy Races in 1935, Harold Neumann, seen here on the left, is reunited with two old friends, NR 55Y and Joe Binder, who purchased the airplane in the 1940s with the intent of racing it himself. (Courtesy of Joe Binder.)

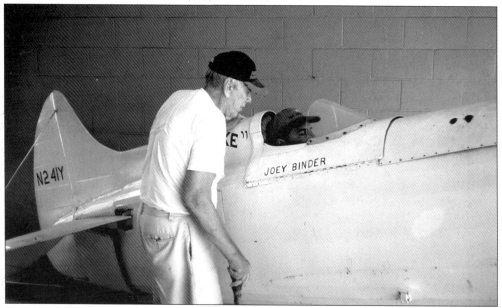

Seventy years after Harold Neumann flew it to victory in the 1935 Greve Trophy Race, *Mike* survives in storage in the Midwest. Here Karl Engelskirger, seated in the cockpit, gains some insight into the experience of flying a golden age racer from Joe Binder, who has owned the Howard racer since the 1940s. (Photograph by Thomas G. Matowitz Jr.)

AFTERWORD

Roscoe Turner announced his retirement from air racing after winning the Thompson Trophy for the third time, in 1939. Aged 43, he said pylon racing was a young man's game and then gracefully walked away. Far from the Corinth, Mississippi, of his youth and the Hollywood of his heyday, he settled in Indianapolis, Indiana, where he ran a very successful fixed base operation for years. His flight school participated in the Civilian Pilot Training Program and sent hundreds of young men off to World War II military flight training armed with an edge they could not have gained anywhere else, the knowledge that Roscoe Turner taught them how to fly.

Gilmore, the lion cub, grew up and eventually weighed nearly 700 pounds, making him far too large for any cockpit. He was returned to the wild animal park where Turner obtained him. As long as the animal lived, Turner sent money every month to pay for his care. Questioned by skeptical friends, Turner explained that the lion had paid his way for so long that he felt obligated to him. Stuffed and mounted, Gilmore is in the National Air and Space Museum. His status as the only lion in the collection of a major aviation museum is likely to remain unchallenged. Roscoe Turner died in May 1970 at age 74. His Laird Turner Racer is in the National Air and Space Museum. The Wedell-Williams racer, which served him so faithfully, is on display at Cleveland's Crawford Auto-Aviation Museum. It is the only surviving example of its type.

The fame the National Air Races brought Jimmy Doolittle never dimmed. Ten years after he gave up air racing on the grounds that it was too dangerous, he conceived and led the single most daring air combat mission of World War II. On April 18, 1942, Doolittle was at the controls of the first of 16 B-25s to launch from the aircraft carrier USS *Hornet*. Their target was Tokyo, which they bombed in the first American counterattack against Japan. Doolittle's detailed report on the mission did not use the word "I" once. Recognition he did not seek came in the form of a Medal of Honor. He went on to command the 8th Air Force with the rank of lieutenant general. After the war, he resumed his career with Shell Oil. In later years, he gave up flying voluntarily but never lost his interest in aviation. Having survived some of the most intense high-risk flying ever undertaken, Jimmy Doolittle lived to become one of the most honored figures in aviation history. He died peacefully in his bed at age 96.

Blanche Noyes was Cleveland's local favorite to win the 1929 Women's Air Derby. She placed fourth. If she was disappointed, she did not show it. In 1936, she teamed with her onetime competitor Louise Thaden. Together they flew a Staggerwing Beech to victory in the Bendix Trophy Race, handily defeating the male pilots who challenged them. Blanche Noyes remained active in aviation for the rest of her life, serving on the staff of the Federal Aviation Administration in Washington, D.C. for many years. She died in 1981.

Steve Wittman continued to race long after his contemporaries chose to retire. In 1979, on the 50th anniversary of the 1929 National Air Races, he appeared at the Cleveland National Air Show not as a fragile exhibit but as a fierce competitor who outflew pilots decades younger than himself. Actively flying into the 1990s, Wittman lost his life as the result of an in-flight structural failure during a routine cross-country flight. His best remembered racer, *Bonzo*, is on display at the EAA Museum in Oshkosh, Wisconsin.

Cliff Henderson, whose skilled promotion made the National Air Races such a remarkable success, also announced his retirement in 1939. He served with distinction in the Second World War, leaving the military as an Army Air Forces colonel. He visited Palm Desert, California, after the war to recover from an illness contracted while serving in Africa. He bought property there and went on to great success as a real-estate developer. He died in 1984. Later promoters carefully noted the marketing strategies Henderson mastered in the 1930s. For many years, air shows and air racing have drawn larger crowds worldwide than any other category of sporting event.

The Cleveland Municipal Airport the air racers knew no longer exists. Extensive renovations beginning in the 1950s have altered the facility beyond recognition, and even its name has been changed. It is now known as Cleveland Hopkins International Airport. The airport originally chosen because it was the largest in the world has become the subject of local controversy because some consider it too small to adequately meet Cleveland's needs. The huge grassy surface that was once the airport's hallmark has been replaced with a massive grid of paved runways and taxiways. The area where the grandstands stood in the 1930s is now the site of a large NASA facility. From the air, the only prominent landmark remaining from the 1930s is the graceful arched bridge that carries Brookpark Road across the valley at the airport's western edge.

The air racers and the vast throngs who cheered them are gone now. The smell of jet fuel has long since supplanted the roar of radial engines, but echoes of the races resound to this day. A generation of boys and girls was inspired to fly. It is estimated that the air races may have led 100,000 young Americans to become aviators in the Second World War. The airplanes they flew to victory were vastly better because of technical advances that resulted directly from air racing. Many women served capably as Women's Air Force Service Pilots during the war, and the standards they set led women to the cockpits of commercial airliners years later and, eventually, to the space shuttle.

The pilots who flew in the National Air Races left a legacy that has benefited the entire world.